A Perfect Lady

A Pictorial History of the
U. S. Coast Guard
Barque *Eagle*

Flat Hammock Press
5 Church Street
Mystic, CT 06355
(860) 572-2722
www.flathammockpress.com

Printed in the United States of America

ISBN: 978-0-9795949-2-2

10 9 8 7 6 5 4 3 2 1

A Perfect Lady

A Pictorial History of the U. S. Coast Guard Barque *Eagle*

*To Captain Lauttit,
my best wishes !*

Tido Holtkamp

By Tido Holtkamp

FLAT HAMMOCK PRESS
MYSTIC, CONNECTICUT

Horst Wessel, 1937

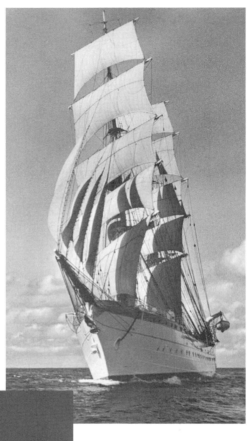

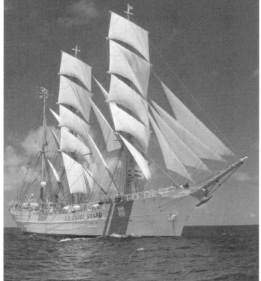

Eagle, 2007

CONTENTS

ACKNOWLEDGEMENTS

Without a great deal of help I could have never compiled and written this book, and I received help from a number of quarters.

There are first and foremost members of the U.S. Coast Guard. Captain David V. V. Wood (Ret.) assisted me from the beginning and became a tireless contributor and editor as well as a checkpoint for much of my background research. Captain Ernst M. Cummings (Ret.) supplied me with a great deal of detail and much encouragement along the bumpy road to my first book. Captain Ivan T. Luke (Ret.) always encouraged me and came up with many photos and good stories. Captain Eric Shaw (Ret.) had an open ear for me and answered all my many requests. Chief Karl Dillman never wavered in his support and gave me help on many, many occasions. Dr. Robert Browning, Chief Historian of the U.S. Coast Guard, and his staff made much of my research possible. Mr. Garrett Conklin made available books and a number of historic photos. Many officers and enlisted personnel of the Coast Guard most willingly answered my questions or pointed out interesting facets of life on board. In the U.S. Coast Guard Academy's library Mr. Richard Everett went out of his way to provide me with background data. Mr. Howard Slotnick gave me an interesting perspective on the politics of it all.

Many of my former German comrades stood by me all through my travails: Hans Westphal, Heinz-Adolf Wagner, Gunther Becker, Willy Starck, Jürgen Gumprich, Werner Rieker, Guenther Bender, Joachim Ditzen, and others. Dr. Mayer Harnisch, now a retired surgeon in California, supplied me many photographs and recollections from his days in 1944 as a Lieutenant on board.

To all of them and to the many other helpers and contributors—too many to list here—my sincere thanks.

Tido Holtkamp
Simsbury, Connecticut

FOREWORD

Although *Eagle* was born just before World War II and her earliest years at sea were unsettled times, for the majority of her years she has been a symbol of peace and freedom. In 2007 she entered her seventy-second year of faithful service. If she could talk, what magical tales she would tell. She has sailed on long journeys, including Australia, South America, and Europe. She has hosted presidents and kings. She has weathered fierce storms and boring doldrums. Most remarkably, however, she has been home to many thousands of cadets. On *Eagle*'s decks, these young men and women have learned to sail, have conquered their fears, and have developed leadership skills they need to serve their country as disciplined military officers. Everyone who has ever sailed in *Eagle* has disembarked with a profound sense of awe for her magnificent beauty and grace, and a tremendous respect for her place in history.

Other books have been written about *Eagle*. Other authors have helped to tell her tales. But Tido Holtkamp brings a unique perspective to the recording of *Eagle*'s history. He is a former German naval cadet and, having come to the United States, served in the U.S. Armed Forces and became a citizen. A lover of sail and sea, he has been a steadfast admirer of *Eagle* for her entire career. Now he steps up to the helm to tell the "Perfect Lady's" story as she has lived it under two flags.

On the following pages, Tido Holtkamp has compiled the most comprehensive history of the ship ever published. His detailed facts, photos, and traditions will give readers a true feeling for the realities of life on board a square-rigger and a deeper understanding of why this ship has been loved by so many for so long. Anyone with a love for sailing, for tall ships, for nautical history, and especially for *Eagle* will be well rewarded in the reading of this book. *Eagle* is fortunate to have such a faithful friend as Tido Holtkamp.

Captain Ernst M. Cummings, USCG (Ret.)
Commanding Officer, *Eagle* 1983-88

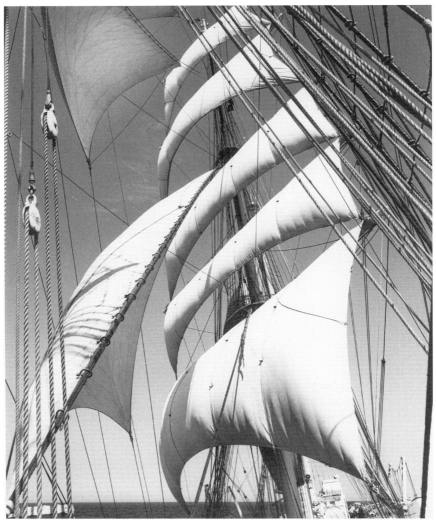

"By the time we got the courses and tops'ls set, we turned our attention to the fo'castle and quaterdeck. We first set the foretopm'st stays'l, and I watched the lubber's line at the steering stand, ordering the helmsman to hold the wheel amidships. By this time we had come around and had the wind two points abaft the beam on the port tack. The bow started falling off to starboard. Without correcting this error in heading, we ran out the lower mizzens'l and the *Eagle*, like a perfect lady, curtseyed and turned obediently to port. This was almost an exactly even balance between the foretopm'st stays'l and the lower mizzens'l."

—Captain Gordon McGowan (USCG Ret.)
The Skipper and The Eagle

PREFACE

When the German Navy drafted me in the fall of 1943, I did not dream that in the middle of a world conflict I would end up spending months aboard a sail-training ship. But I did, and I fell in love with tall ships, sailing, and the sea.

Following World War II, I came to America as an immigrant, and, after a stay in New York and an unexpected draft into the U.S. Army, I settled in Connecticut. Imagine my surprise when in 1956, while driving over the Gold Star Bridge in New London, I suddenly spotted my old ship, *Horst Wessel*, at the U.S. Coast Guard Academy. She looked as trim as ever, and her beautiful lines had not lost any of their graceful curves. Her new name was also fitting, *Eagle*.

I have gone to New London many times since, have sailed on her often, and have come to know many of the captains and her crews. All the while I have remained in close touch with my old shipmates in Germany. As a result I have been able to collect many mementoes, facts, stories and photographs of her past.

In his book *The Skipper and The Eagle*, Captain Gordon McGowan wrote about using the different sails to balance the steering of the ship and concluded that by setting certain sails he could make *Eagle* curtsy like "a perfect lady."

I could think of no better title for this book, which is not meant to be a detailed history, but rather a celebration of a beautiful ship and an expression of my admiration for the people who have crewed and cared for her.

Tido Holtkamp

First Voyage

What do you want from me then, you magnificent ship?

What do you stretch so high, your wings?

And steer so safely 'round cliff and reef,

And slide from height to height?

And I stand way up, high on the yard,

And I am so close to my God and to Heaven,

I can barely contain my joy!

From a poem by Rudolf Kinau
(Brother of Johann Kinau, whose pen name was Gorch Fock)
Translated by Tido Holtkamp

At Right: Barque *Eagle*'s seal highlights: Tradition; Seamanship; Character. Her designation is WIX, the Coast Guard abbreviation for an auxiliary training vessel. Her hull number is 327.

Introduction

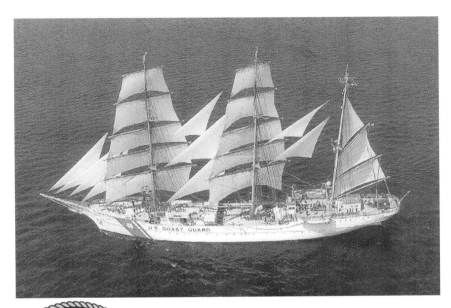

Since 1946, the U.S. Coast Guard has used the Barque *Eagle* for training their cadets and officer candidates. *Eagle* serves as the only tall ship in a military service branch of the U.S. Armed Forces. Over the years she has represented the United States of America at birthday and anniversary celebrations of states and cities not only in the United States, but all over the world. She has led many tall ship parades and has acted as the U.S. ambassador on numerous other occasions. Her gracious lines have made her a favorite subject for photographers of all ages; her beautiful hull, her white sails, and the blue water have proved irresistible to many artists. Her pictures grace thousands of homes and businesses in the United States and abroad. People have come to know and love the U.S. Coast Guard Barque *Eagle* as "America's Tall Ship."

This proud ship once flew the flag of German Navy. Apart from a few clues that can be found on board, not much else has changed.

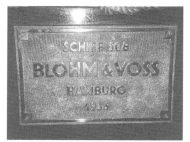

The original builder's plate from *Horst Wessel* can be found in "Officer's Country" on board *Eagle*

The builder's number 508 is also embossed on the foremast.

If you remove the *Eagle* plate from the steering wheel, you will find another plate under it with the inscription Segelschulschiff *Horst Wessel*.

The evolutions and skills required to sail *Eagle* have not changed in over 70 years.

At right, boat operations circa. 1937.
Below, boat ops, circa. 1970.

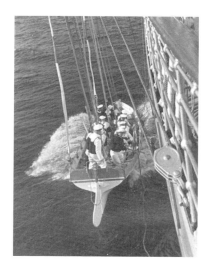

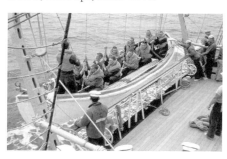

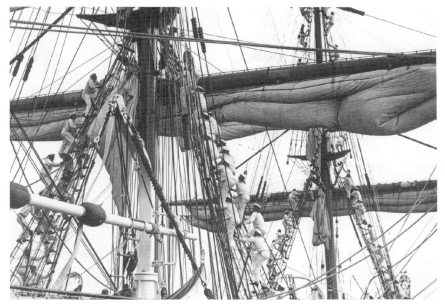

German cadets in the rigging aboard *Horst Wessel* in 1938.

U.S. Coast Guard cadets in the rigging aboard *Eagle* in 1964 (left), and today.

U.S. Coast Guard cadets today.

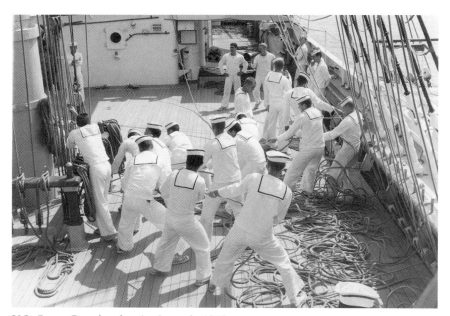

U.S. Coast Guard cadets in the early 1960s.

I. Sail-Training in Germany

Even before Germany united, the small navy of Prussia had established a sail-training program for cadets. The corvette *Amazone* served as the first major school ship for cadets until she perished in a storm in 1861.

During the Franco-Prussian War of 1870-71, the crafty Prussian minister Otto von Bismarck managed to draw the other German lands into the war on Prussia's side, and in 1871 they all voted to join into a united Germany and to appoint Wilhelm, King of Prussia, the new Emperor of Germany.

The newly constituted German Imperial Navy, like many other navies of the time, also placed heavy emphasis on the sail-training of cadets and boys. A number of ships served as sail-training ships and most of them included visits abroad in their curriculum. Such a ship was the SMS *Stein*, a 2,800-ton training ship with a crew of up to 460 men and cadets.

In 1904, the German Navy built a new Naval Academy in Mürwik by the Flensburg Fjord near the Danish border. An officer candidate would go through four months of basic training, spend six months on board a sail-training ship, attend the Naval Academy for six months, get further schooling depending on specialty, have a ship assignment with duties as a junior officer, and (after 2-3 years) receive promotion to Lieutenant.

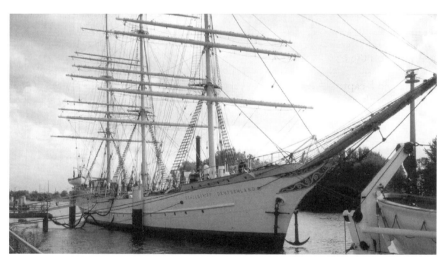

The merchant marine, too, used sail-training ships (the *Deutschland* is now a museum ship in Bremen) for the training of future officers. German merchants had become famous for their freight sailing ships, which made fast runs from Europe to South America around the feared Cape Horn and back. The Flying P-Line ships of the firm Laeisz broke one speed record after the other and successfully competed with steamships for years. One of their ships, the *Peking*, now serves as a museum ship in New York City.

During the World War I the British blockade shut down all overseas access to Germany, and German ships remained restricted to German coastal waters and the Baltic, except for some daring blockade-runners.

One of them, Count Felix von Luckner, electrified not only Germany, but the whole world, when after the war he published his adventures in the book *Sea Devil*. As a young boy he had run away from home and gone to sea. After many years on ships from different nations and some exciting adventures he worked his way up to the rank of officer and in 1912 obtained a commission in the Imperial German Navy. In 1916, he took part in the Battle of Jutland. Later that year the Admiralty asked him if he could take a sailing ship,

THE AMAZING TRUE STORY OF IMPERIAL GERMANY'S GENTLEMAN PIRATE

The Cruise of the SEA EAGLE

Blaine Pardoe

break through the British blockade, and act as an auxiliary cruiser to disrupt Allied sea traffic on the ocean lanes. Von Luckner jumped at this opportunity.

He selected a captured American full-rigged three-masted sailing ship and had her equipped with a motor, secret compartments, and loads of fuel and provisions. With a carefully selected crew, and with detailed preparations, he passed through the British blockade by posing as a Norwegian ship and deceiving a British boarding commando.

Once in the open Atlantic, he dropped his Norwegian disguise, hoisted the German Flag, and with his new ship the *Seeadler* (Sea Eagle), he began to capture and sink Allied ships, using one ruse or another. In each case he and his men exercised extreme care not to hurt anyone; he would sink a vessel only after he had taken the crew on board his ship, where he treated them well. After a number of sinkings he put all his prisoners on a captured vessel and sent them off to Rio de Janeiro.

Eventually, his British pursuers closed in on von Luckner, and he had to escape into the Pacific, where he continued his activities, sinking mostly American ships. Lying off the atoll of Mopelia, the *Seeadler* got dragged onto a coral reef, which destroyed the ship and forced the crew and their prisoners into a strained co-existence on the island.

With a handful of shipmates he crossed the Pacific in an open boat, but got caught just as he was about to capture a ship. He later escaped from a prison in New Zealand but was re-captured. After the war the Allies repatriated him and his crew to Germany.

Von Luckner's book with its adventurous spirit and humane attitude towards his enemies won him many friends throughout the world, and in Germany he re-ignited patriotism as well as interest in sailing and the sea. He had defied conventional wisdom and used a sailing vessel as a cruiser! It came as no surprise that in 1921 the German Navy picked him to captain the Navy's sailing ship *Niobe*.

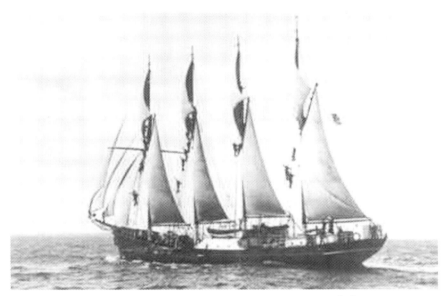

A U-Boat had seized the Norwegian four-masted schooner *Tyholm*, originally the Swedish *Morton Jensen*, as a prize in 1916. After the war the German Navy, stripped by the Treaty of Versailles of most of her assets, put the ship into service as a tender under the name *Niobe* and gave the command to Kapitänleutnant von Luckner. After two years von Luckner took his retirement and went on to other pursuits.

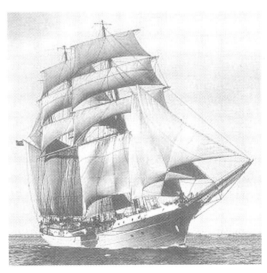

As the German Navy badly needed a new sailing ship for training, the *Niobe* was re-built and re-fitted in 1922 into a three-masted schooner of 700 tons with square sails on the foremast and main mast and a lead keel for better balance. Critics called her a "jackass barque" and complained that the ship had become top-heavy. With a crew of 32 and room for 69 cadets, the ship became the Segelschulschiff *Niobe* of the German Navy. During the 1920s she sailed mainly in the Baltic.

All went well for 10 years. Then, on July 26, 1932, on a sunny day off the island of Fehmarn and in view of many spectators, a sudden squall caught the ship and pushed her on her side. Within 30 seconds the sails hit the water, the ship capsized and quickly sank. Of the personnel on board, 69 died; only 40 men, including the captain, were saved.

The tragic sinking sent shock waves throughout Germany. The captain had to face a court, but was acquitted. The grave marker over the graves said simply: "Don't complain, try again!" In Germany, public collections and sales of *Niobe* coins quickly brought in donations totaling 200,000 marks towards the construction of a new segelschulschiff, a new sail-training ship.

The Admiralty, under public and time pressures, awarded the construction of the new ship to the well-known and well-respected shipyard Blohm & Voss in Hamburg.

II. The Shipbuilders
Blohm & Voss

By 1850, the old Hanseatic city of Hamburg in northern Germany, situated on the Elbe River and 50 miles from the sea, had grown into a booming major port, with many shipping companies, and with much commerce. But when it came to building iron ships, England was the place to order them, and German shipyards would leave such building to the British.

Born in 1848 in Lübeck, the son of a merchant, young and enterprising Hermann Blohm decided early on to change that. After extensive schooling and training in Germany he went to England in 1873 and worked in several shipyards and engineering firms. When he returned to Lübeck in 1876, he found no takers for his grand plans. He moved to Hamburg, where he met the man who was to become his partner for life.

Ernst Voss also had studied engineering and shipbuilding, and he had spent time in England learning the most advanced shipbuilding methods and techniques for iron steam ships in the world. Blohm had become a first-rate shipbuilding engineer, while Voss had specialized in designing steamships. They met in 1873, quickly developed a bond of common interests, and decided to jointly construct a shipyard.

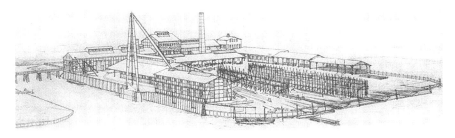

The partners founded the Blohm & Voss shipyard in Hamburg, a city, at that time, of merchants, but not very interested in shipbuilding. They erected the yard on low-lying land that they first had to fortify against flooding. Their enterprise, as they saw it, had to have not only a yard, but also a machine shop. For the machinery the partners went to England. Finally, in 1878, Blohm & Voss was ready.

While they survived the first years with the construction of sailing ships, docks, and repair work, they finally received, in 1888, their first order for a steamer from the Hamburg-America-Line. Within a year the shipyard proudly delivered the *Croatia*, which registered 2,052 tons and, a testament to the workmanship, remained in service for seven decades.

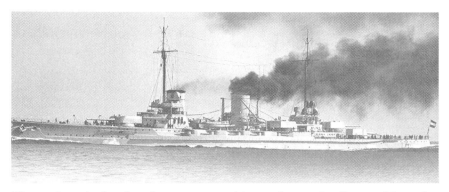

The yard received orders for more steamships, and soon the German Navy also placed orders with Blohm & Voss. The yard delivered the 21,000-ton battle cruiser *Moltke* to the German Navy in 1911. The *Moltke*, leading a German squadron, visited the U.S. in 1912 and received President Theodore Roosevelt on board in Hampton Roads, Virginia. The ships then encountered a warm reception in New York City. Blohm & Voss also built sailing ships, among them several of the famous Flying P liners of the Laeisz Line.

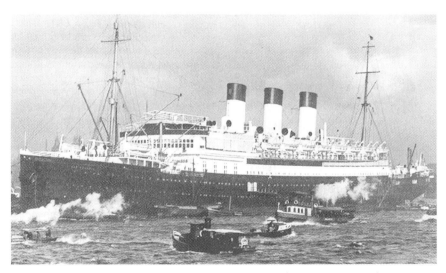

After World War I, the yard built the beautiful *Cap Polonio*, the *New York*, and other ships; by 1927 the company had built 130 merchant and 200 warships (mostly submarines). In 1930 the *Europa*, almost 50,000 tons, and equipped with four turbines from Blohm & Voss, left for a test run, admired by millions of spectators along the Elbe river; then on her maiden voyage to New York with 2,200 passengers and a crew of 950 the steamer reached speeds of 28 knots and garnered the "Blue Ribbon," awarded for the fastest transatlantic crossing, from her sister ship *Bremen*.

For the company, the depression brought financial stress and a lack of orders, for the workers, reduced work hours and cuts in pay. All the while Blohm & Voss built freighters, passenger ships, and tankers for commercial customers. After Adolf Hitler came to power, however, business began to bloom as Blohm & Voss received orders from the German Navy for warships including submarines, for seaplanes, and a gigantic dry dock.

With the outbreak of the World War II, Blohm & Voss once again had to change gears: no more merchant vessels, only warships, especially submarines. In 1940 the first BV 222 flying boat passed all tests. In the same year the yard delivered the gigantic battleship *Bismarck* to the navy. Almost 800 feet long and 118 feet wide, she displaced over 50,000 tons fully equipped, and with eight 15-inch and twelve 6-inch guns, *Bismarck* became a big threat to Britain's Royal Navy.

In May 1941, *Bismarck*, after sinking the British battleship *Hood*, lost her steering when a torpedo from carrier planes hit the rudder. Soon the British fleet surrounded her, and *Bismarck* finally went down in a hail of guns and torpedoes; only a handful of her crew was saved.

Bismarck's keel was laid July 1, 1936 as hull #509. *Horst Wessel* was hull #508.

By April 1943 the yard employed 17,000 workers, but in the summer came "Operation Gomorrah," a series of murderous air attacks on Hamburg by the British and American air forces. More than 3,000 planes dropped over 4,000 tons of explosives and the same amount of incendiaries. One night a gigantic firestorm killed 45,000 people. The raids also damaged the Blohm & Voss yard extensively, but the yard soon resumed the building of U-Boats. Constant air raids, however, severely limited production, and the yard could only build a handful of the new Type XXI U-Boats.

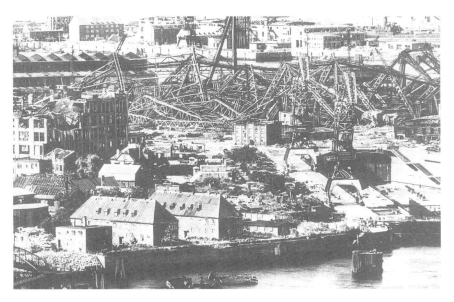

When, in May 1945, British troops took Hamburg, they immediately occupied the Blohm & Voss premises and ejected all employees. The British carted off all important documents and all usable equipment, destroyed the rest and blew up the buildings. By 1950, however, Blohm & Voss received permission to begin the manufacture of machines and other goods—a new beginning.

During the second half of the 20th century Blohm & Voss thrived again and underwent several mergers. Over the decades the yard produced passenger ships, freighters, and container ships, and, eventually again, warships.

III. The New German Sail-Training Ships

After the 1932 sinking of the *Niobe*, the German Navy selected the Blohm & Voss shipyard to build a replacement segelschulschiff as soon as possible, because the traditional sail-training of the officer candidates must continue. Blohm & Voss immediately began with the design of ship #495 (Blohm & Voss assigned sequential numbers to all the ships they built.)

In the past, the German Navy had used mostly ships for sail-training that had originally been designed and built as regular ships of the fleet; the German Merchant Marine, too, had put regular freight ships into service for sail-training that sometimes continued to be used for freight also. In 1932, however, the charge to the shipyard was very clear: build us a ship for sail-training only, forget all other uses such as freight, armament, training on guns and torpedoes, and so on. So the shipyard had the liberty of ignoring many traditional restraints and concentrate on designing a ship exclusively for sail-training. But the ship had to be built so that another catastrophe such as the *Niobe* sinking would be impossible.

Blohm & Voss settled on the three-mast barque: two masts fully rigged with "square" sails, and one mast with "fore-and-aft" sails:

Mizzenmast Mainmast Foremast

26

This type of ship, called a "bark" or "barque," derives very good sail power not only from the huge surfaces of the "square" sails, but also additional sail power and great maneuverability from the "fore-and-aft" sails. In terms of manpower the "fore-and-aft" sails of the mizzenmast can be managed entirely from the deck below (which would be important in case of emergency); the "square" sails on the foremast and mainmast, however, require that men climb up into the rigging and onto the yards to unfurl and furl the sails.

Blohm & Voss built the ship in a record time of 100 days. The yard utilized a new procedure for putting the ship together: it prefabricated individual sections of the hull and then assembled them on the keel. The ship was officially launched in May 1933 and named Segelschulschiff *Gorch Fock* after the well-known poet Johann Kinau, who, under the pen name Gorch Fock, had written the best seller *Seefahrt ist Not* (Seafaring is Necessary). Kinau died in the 1916 Battle of Jutland and lies buried on a small Swedish island of Stensholmen, where many Germans still visit his grave.

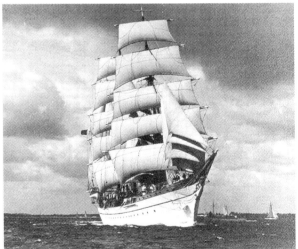

Segelschulschiff *Gorch Fock* entered service on June 27, 1933 under Captain Paul Mewe as Kommandant. At first the ship, mindful of the *Niobe* disaster, had orders to sail always in sight of land, but finally the captain lost his patience and demanded freedom to take her on the high seas. Admiral Erich Raeder relented, and so the *Gorch Fock* eventually undertook several cruises to Scandinavia and into the Atlantic.

Adolf Hitler came to power in Germany in 1933. He soon renounced Germany's obligations to the infamous Treaty of Versailles and began a general rearmament. The navy also began to expand, and demand grew for more officer candidates. In 1935 the navy ordered another segelschulschiff, another sail-training ship.

Since the *Gorch Fock* had proved very seaworthy and stable, her plans also served as blueprints for the new ship, but with slightly larger dimensions.

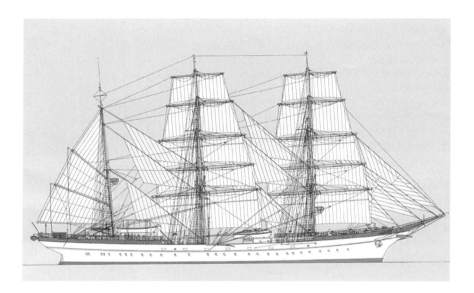

Her hull had outer walls made of steel plates; the masts and yards were also made of steel (the yards on the *Gorch Fock* were made of wood). The ship had two full-length steel decks, the main deck overlaid with solid teak and the second deck overlaid with Oregon pine. Six bulkheads provided for seven watertight compartments, and the ship carried 300 tons of solid ballast to prevent capsizing. The tops of both fore- and mainmast contained movable sections that could be lowered when passing under the bridges over the Kiel Canal (connecting the North Sea with the Baltic Sea). In addition, the top three yards of the fore- and mainmasts were movable. When not sailing they were kept in a lowered position to lower the ship's center of gravity, but when used for sailing, the yards were lifted up.

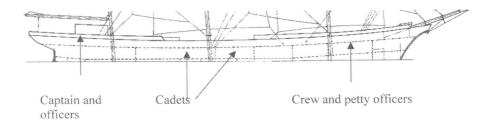

Captain and
officers

Cadets

Crew and petty officers

The ship was planned for 80 officers and men as well as up to 220 cadets. The quarters and wardroom for the captain and the officers ran under the quarterdeck (toward the stern). The cadets lived in four large compartments amidships on the second deck, each housing 50 cadets who slept in hammocks. These compartments carried steel lockers for the cadets' gear; mess tables and benches, installed on the ceilings, could be taken down for meals and recreation. The petty officers and the crew had their quarters under the foredeck. All quarters were steam-heated. The galley came equipped with electric ranges and refrigeration.

When the time came for naming the ship, the leadership of the Reich stepped in. While the German Navy usually could chose a name for a new ship, the naming of the sail-training ships, intended to teach the young people, was another matter. The Reich leaders decided that henceforth all sail-training ships would be named after heroes of the National Socialist movement, and the new ship would be named Segelschulschiff *Horst Wessel*.

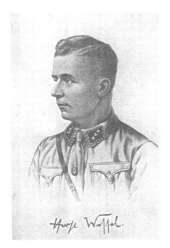

Born in 1907 in Bielefeld (northwest Germany), the son of a Protestant pastor, Horst Wessel moved to Berlin as a student and became an ardent follower of the National Socialist German Workers Party (better known as the Nazi Party) and its leader, Adolf Hitler. Horst Wessel joined the brown-shirted Storm Troopers in a predominantly Communist sector of Berlin, and advanced to a leadership position. He wrote a rousing and stirring song, which became the fighting song of the Storm Troopers. The first verse:

Hold high the flag! Keep the ranks tightly closed!
Storm Troopers march in firm and even step.
Our comrades, whom Red Front and Reaction have shot dead,
Are marching with us in spirit.

In 1930, Horst Wessel met a young girl of questionable reputation, who gave up her trade and moved in with him. One evening a group of Communists came to the door to evict him. One of them, a former lover of the girl, pulled a pistol and shot Wessel. He died a short while later.

At that time the fortunes of the National Socialists had hit low ebb in Berlin, and Joseph Goebbels (at the time a local leader, and later was Nazi Propoganda Minister) saw in the young man's death a perfect opportunity for publicity. He announced a public funeral for Horst Wessel with a huge assembly of his Storm Troopers. When the Communist Party threatened to disturb the funeral procession, radio, film, and press decided to cover the event, and the funeral became a big publicity success for the National Socialists.

After Adolf Hitler took over power in Germany, the National Socialists appended the "Horst Wessel Song" to the "Deutschland Über Alles" national anthem, so that throughout the Third Reich the German national anthem consisted of two songs. (Later in World War II the Waffen SS created a Horst Wessel Division)

The Segelschulschiff *Horst Wessel* was launched and christened on June 13, 1936. A large crowd, naval units, Storm Troopers, and Adolf Hitler himself attended the ceremony; his deputy Rudolf Hess gave the dedication speech. Under the rousing sounds of the "Horst Wessel Song" the ship slid into the water.

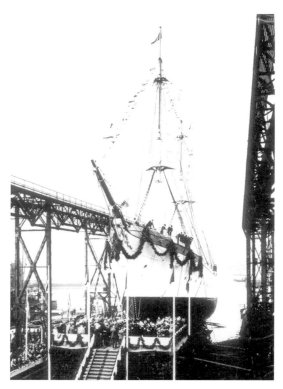

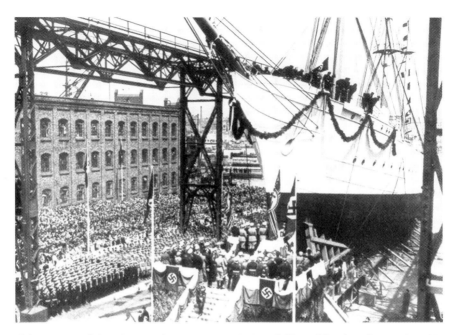

After successful trial runs, the navy commissioned *Horst Wessel* on September 17, 1936 with Kapitänleutnant August Thiele her first Kommandant, and Kiel the homeport.

Soon the German Navy had Blohm & Voss build another segelschulschiff; this ship was commissioned in 1937 as Segelschulschiff *Albert Leo Schlageter*, also in the presence of Adolf Hitler. In 1939, Blohm & Voss delivered the *Mircea* to the Romanian Navy, and in 1939, began work on Segelschulschiff *Herbert Norkus*. With the outbreak of the war, all work on *Herbert Norkus* ended.

Albert Leo Schlageter was a German officer who, in 1923 blew up a train transporting coal to France. He died as a martyr figure for Germany when the French executed him for sabotage. Mircea was the name of an ancient ruler of the Romanian region of Europe. Herbert Norkus died in 1932 as a Hitler Youth in a street fighting altercation with Communists.

The following table provides detailed comparisons between the sister ships as well as a detailed sketch showing all the sail plan of the *Horst Wessel*.

	Gorch Fock	Horst Wessel	Albert Leo Schlageter	Unit of Measure
Commissioned	June 7, 1933	Sept. 9, 1936	Feb. 2, 1938	
Length overall	269	294	294	feet
Length bow to stern	242	267	267	feet
Length waterline	203	230	230	feet
Freeboard	7.6	8.8	8.8	feet
Draft	17	17	17	feet
Largest mast height	139.5	148.6	148.6	feet
Largest spar length	80.7	78.7	78.7	feet
Volume	1330	1500	1500	tons*
Displacement	1534	1755	1755	tons*
Fuel	28	40	43	tons*
Anchors foredeck	3528	3858	3858	lbs
Motor	540	750	750	PS
Bowsprit	29.5	31.5	31.5	feet
Sail area	19,343	21,248	20,817	ft²

*metric tons

This table from the *Instruction Booklet* given to German cadets in the 1930s shows not only the major dimensions of the *Horst Wessel*, but also a comparison with her sister ships. The *Horst Wessel* and the *Schlageter* were sometimes called the Horst Wessel Class. By 1939, Blohm & Voss had completed four sister ships and had started work on a fifth, the *Herbert Norkus*. They all had the same arrangement of sails as shown on the sketch below, also from the *Instruction Booklet*. Only the *Gorch Fock* carried a single spanker sail.

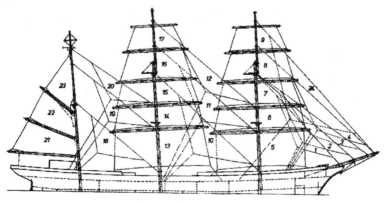

18. mizzen staysail	10. main topmast staysail	1. flying jib
19. mizzen topmast staysail	11. main topgallant staysail	2. outer jib
20. mizzen topgallant staysail	12. main royal staysail	3. inner jib
21. lower spanker	13. mainsail	4. fore topmast staysail
22. upper spanker	14. main lower topsail	5. foresail
23. gaff topsail	15. main upper topsail	6. fore lower topsail
	16. main topgallant	7. fore upper topsail
	17. main royal	8. fore topgallant
		9. fore royal

The sails number 21 and 22 are known as lower and upper spanker; the sailors call that a "split spanker." *Gorch Fock* started with one spanker sail on the mizzenmast, all other sister ships started with a split spanker. These "split spankers" created some controversy in *Eagle's* later life.

IV. *Horst Wessel*
1936-39

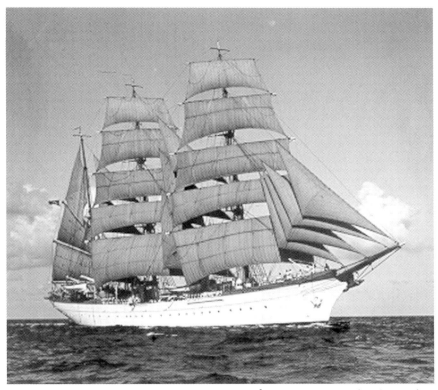

After a trial run the Segelschulschiff *Horst Wessel* was commissioned in September 1936. Her first captain, Fregattenkapitän August Thiele, had previously commanded the sister ship *Gorch Fock*.

During the 1930s, *Horst Wessel* served as a sail-training ship and undertook a number of cruises. The training schedule alternated between officer candidates and petty officer candidates.

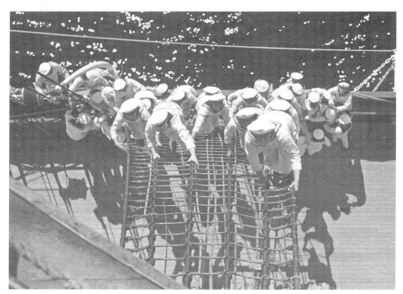

Soon the ship had her first contingent of new cadets, who had just arrived from four months of grueling basic training. Getting up the mast to the sail stations for the first time presented the cadets with a new experience. But soon, working in the rigging became a daily exercise and made the young men familiar with their new world—the world of sailing. After weeks of sail exercises the young crews were ready for their sail cruise.

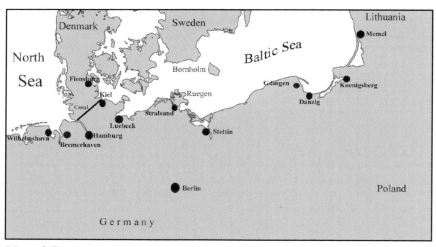

Map of Germany's major naval ports 1933-45.

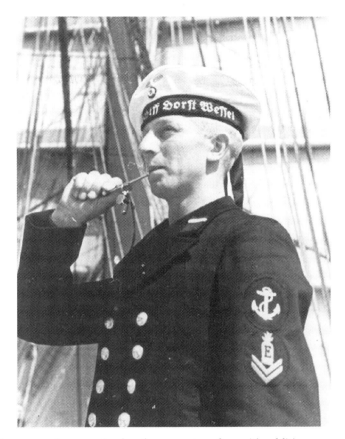

On *Horst Wessel* all commands were piped and sung out—often with additions —such as Reveille:

> *Rise, Rise, get up!*
> *Every man kick his neighbor!*
> *The last one kick himself! Rise, rise!*

Or Lights out:

> *Quiet in the ship! Lights out!*
> *All ghosts to their stations! All dying sailors line up on deck to receive caskets!*
> *Quiet in the ship! Lights out!*

And always welcome:

> *Bring down the tables and benches!*

Note that in peacetime a sailor's hat carried the ship's name.

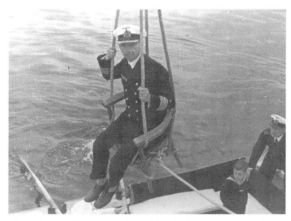

Here Captain Thiele demonstrates use of the "bootmannstuhl" or boson's chair. It was used to lift visitors, often ladies, on board.

In peacetime the captain also had his own little sailboat on board, the so-called "sharpie," which he would use to compete in sailing regattas.

Maintaining and cleaning the "sharpie" was a job highly desired by the cadets and usually a mark of distinction.

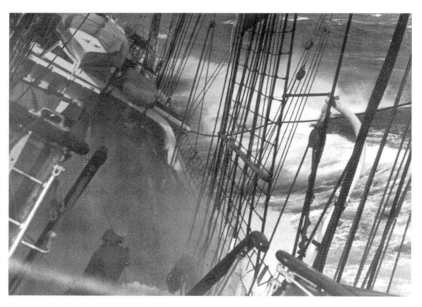

After additional trial runs and inspections, *Horst Wessel* took a trip through the Baltic Sea. Then, in December 1936, she sailed into the wintry Atlantic and visited Las Palmas in the Canary Islands. On the way back in January, she ran into a winter storm with gale force winds in the North Atlantic; at one time the captain ordered oil to be poured into the sea in order to obtain some relief. The vessel returned to Kiel in February, 1937.

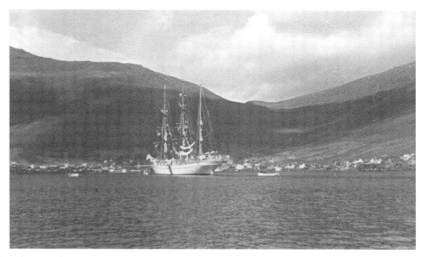

The ship made a number of trips to the Baltic, Norway, the Faeroe Islands, and Iceland. While the cadets came to appreciate the beauty of sea and land, they also got to know foreign countries, their people and habits. With the unpredictable weather in these regions, the cadets really learned how to handle themselves and the ship in sunshine and storm.

Every cadet had to keep a personal "log book" while on board and was encouraged to write down his impressions and experiences every day. The artists among the cadets took these opportunities to add their artwork to their entries. Here cadet Jacob shows his impression of Iceland.

Cadet Jacob took a special liking not only to the wild beauty of the Faeroe Islands (halfway between Scotland and Iceland), but also to their inhabitants. He noted that "they are very friendly, speak mostly English, some German; learn Danish in school, but their conversations are in Faeroese, which has nothing in common with Danish."

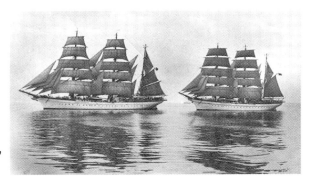

Horst Wessel and *Gorch Fock* under way in 1937.

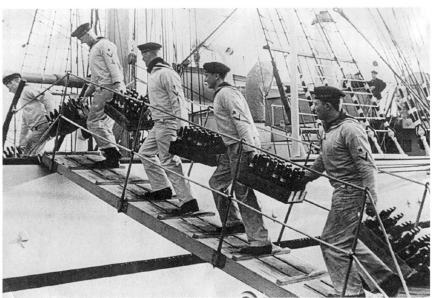

Port calls meant provisioning the ship. Here, German cadets composing the "beer squad" of *Horst Wessel*'s sister ship *Gorch Fock*, bring aboard a load of amber brew for their thirsty shipmates.

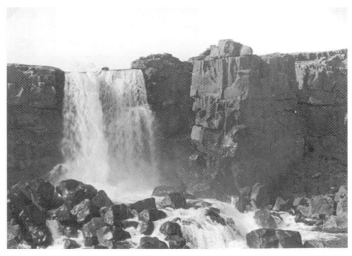

In Iceland the cadets could delve into Old Norse history and customs. The "Thing Place" used to be the scene of many assemblies and struggles. The falls nearby provided a dramatic picture.

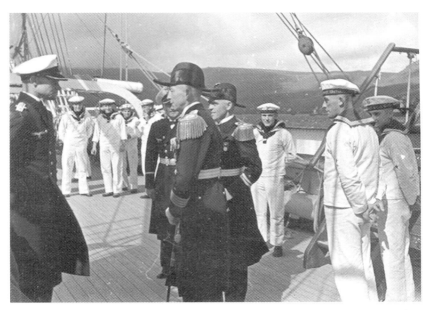

Trips abroad honed not only the seamanship skills of cadets and crew, they also brought exposure to other countries and customs. For the officers it meant an opportunity to polish up on diplomatic manners. Here, the captain and some officers are about to leave the ship for an official visit ashore.

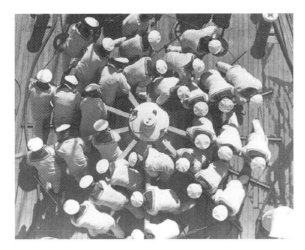

When the time came to leave, the watch on duty would bring up the anchor by working the capstan: each 2½ turns would bring up one meter of anchor chain, and the chain could easily be out for 200 meters. Sometimes two anchors had to be brought up.

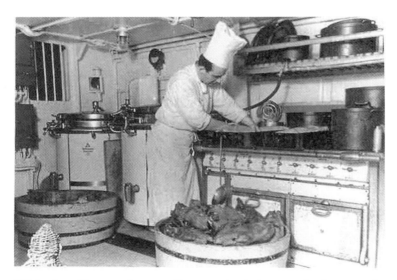

While the officers and petty officers ate in their respective lounges, the cadets ate their meals at their tables in their decks. These tables and benches were normally fastened to the overheads, but during meals and evenings they were taken down and set up—one table for each 10-men section. Each table would send a designated meal carrier to the kitchen. The cook had more than enough to do to feed almost 300 hungry mouths every day. The photo shows the "smutje" (cook) preparing lunch, the main meal in the German Navy. The navy frequently enhanced the diet either by a bottle of good German beer or some tea with rum.

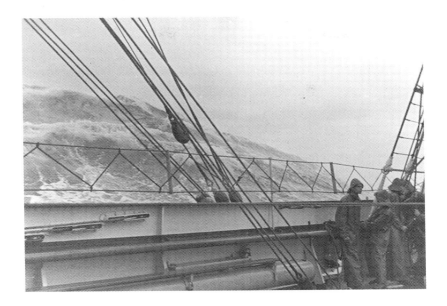

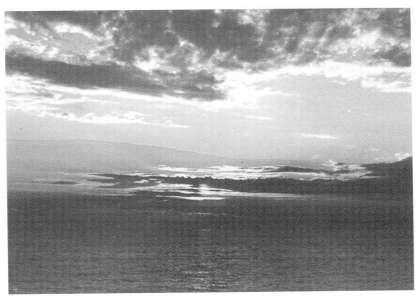

While on a cruise, the cadets learned that the sea is an ever-changing element, stormy and dangerous at one time, peaceful and serene at another. Here the photos show a wild storm and a peaceful sunset.

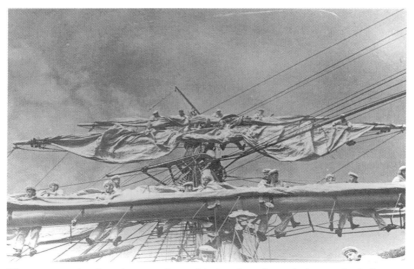

The constantly changing weather with its changing winds required the constant adjusting of the sails: furling them, unfurling them, often repairing them, and also hauling or loosening the lines controlling the sails. Working up in the rigging required concentration and teamwork, but also care; the old saying "One hand for the ship, one hand for the sailor" certainly held true.

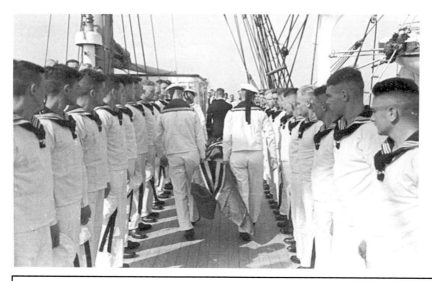

Off Copenhagen on a sunny, calm day in July 1937 cadet Fritz Neumann fell to his death from a spar. The ship returned to port and cadets carried the casket ashore for a funeral that the whole crew attended.

The fear of losing a man over the side called for constant "save the man" exercises; often a dummy lifesaving ring would be thrown overboard, the cry "Man Overboard" would ring out, the boat would be lowered, and the boat crew would have to find the ring, retrieve and return it. This maneuver remained fairly simple as long as the sea remained calm; in heavy seas the life saving exercise could become dangerous.

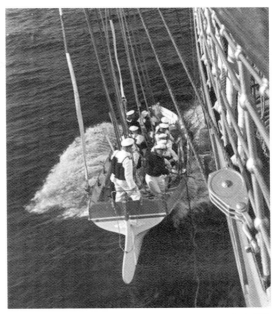

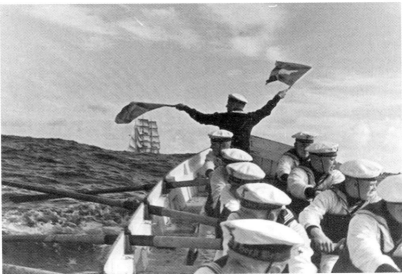

In the case of "Man Overboard," the ship was usually under sail, and slowing down a big sailing ship took time. The lifesaving boat might quickly find itself quite a distance away from the ship and remaining in touch became a problem, especially since radios were not available. In this case, the signal flags were employed.

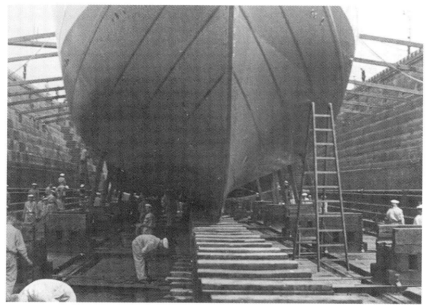

In between trips the ship sometimes went back to Blohm & Voss into dry dock for updates, repairs, and the inevitable bottom cleaning. In fact, during the three pre-war years the ship underwent repairs five times.

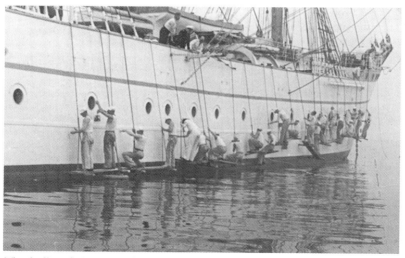

The hull and the upper structure suffered from exposure to sun, salt, and wind; keeping the ship in good shape required constant work. Here the starboard side of the hull receives some loving attention with paint.

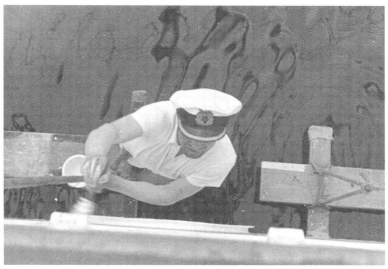

Just to show how important the paint job was, even the executive officer joined in the work alongside.

Not everything was work and danger; many times life on the ship also brought relaxation. Here the supply officer is caught taking a nap.

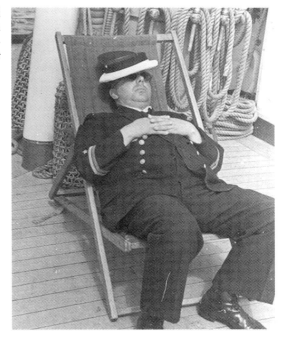

Ducks were kept on board for eggs and for a meal. When let out of the coop they would often soil the deck..

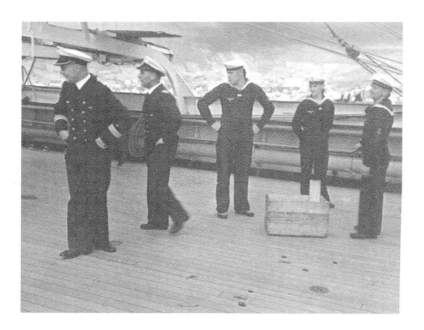

The *Horst Wessel* also hosted training courses for enlisted men about to become non-commissioned officers. These courses would also teach seamanship and sailing, but since these men had already served for several years, the training course ran only two months. These pictures come from the "log book" of Günther Tiegs, a sailor. The photo shows him after his promotion to Bootsmann (Petty Officer 1st Class or Boatswain).

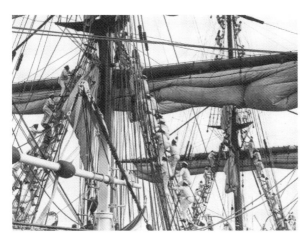

As the photo shows, the NCO candidates acted and looked exactly like the traditional cadets. The future NCO's experienced the same strict discipline, the same sail exercises, and many of the same classes cadets were given. Their immediate superiors were the same non-commissioned officers who also commanded the cadets.

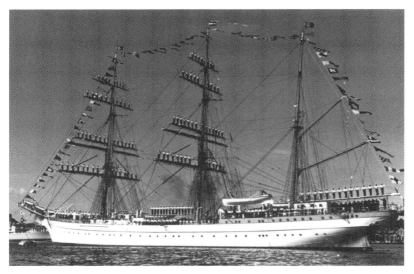

Because of the growing demand for naval officers, the German Navy ordered a third sail-training ship, launched and christened in October 1937 as Segelschulschiff *Albert Leo Schlageter*. Her dimensions closely resembled those of the *Horst Wessel*, which is shown here at the parade following the ceremony.

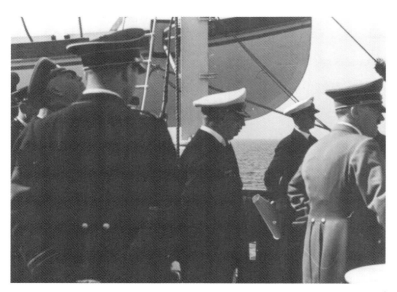

Adolf Hitler, then Chancellor of Germany, came on board *Horst Wessel* once, but only stayed for an hour. Captain Thiele is said to have remarked afterwards, that he did not like the man's fluttering eyes.

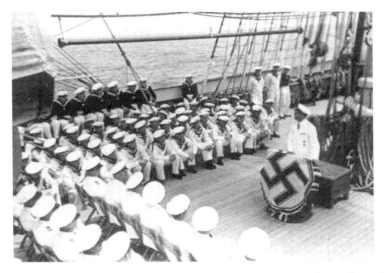

The new Military Code of 1935 made "Aryan" descent a precondition for active service; thus Jews, with some exceptions, could not remain on active duty. The Code also forbade soldiers from participating in political activities and from active membership in any political party including, surprisingly, the Nazi party.

In November 1918 some crews on the battleships of the Imperial Navy had revolted, thrown officers over board, and hoisted Communist red flags. This revolt had brought about the Kaiser's abdication and hastened the German surrender.

Ever mindful of this blot on their reputation, the German Navy went out of its way to show its allegiance to the State. In the Third Reich it did this by actively supporting the aims of the Nazi party and by celebrating Hitler's birthday with an assembly of the crew in Class A uniforms, and with a speech by the Kommandant extolling the greatness of the Führer and his movement. Medals and promotions were also awarded during this ceremony. For lunch, officers and petty officers sat with the cadets, and the afternoon brought shore leave for everyone.

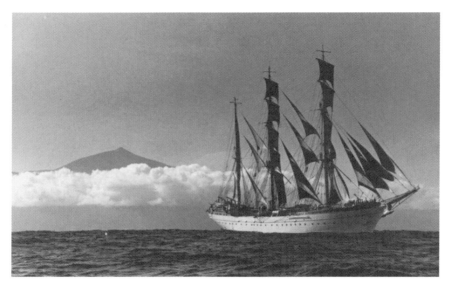

From March to June 1938 *Horst Wessel* and *Albert Leo Schlageter* undertook a long cruise to the Caribbean, visiting St. Thomas and Venezuela. The trip took 10,500 sea miles; *Horst Wessel*'s crew proudly reported that they had caught two "huge" sharks and three large turtles.

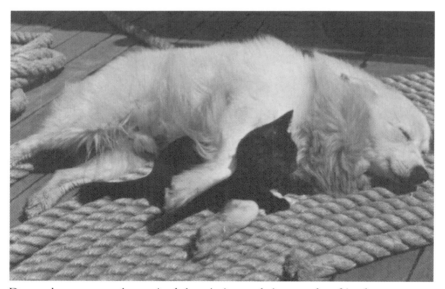

Dog and cat apparently survived the trip in good shape and as friends.

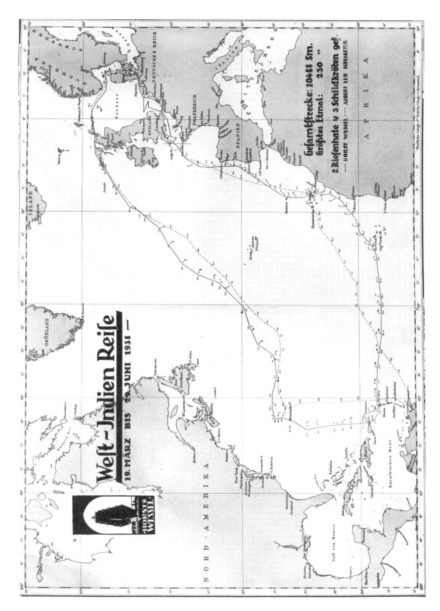

The above map shows the tracklines for both *Horst Wessel* and *Albert Leo Schlageter* from March 19 to June 29, 1938.

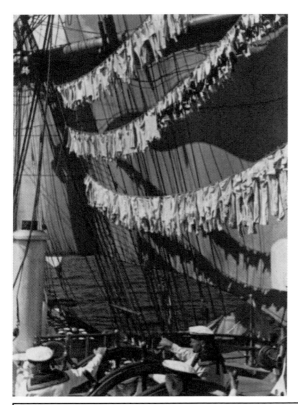

Obviously such a long trip required a lot of laundering along the way, and without laundry machines on board all laundering had to be done by hand, and sometimes in saltwater. Drying the laundry presented another problem, and sometimes the ship's lines carried an unusual load.

In late 1938, the *Horst Wessel* undertook a Christmas cruise to the Azores. On New Year's Eve a yeoman of the crew hanged himself in the galley storage. His body was sewn into his hammock and in the morning, after an elaborate ceremony, buried at sea.

In 1939, under a new captain, Kurt Weyher, *Horst Wessel* undertook several more cruises to Portugal, the Canary Islands, the Faeroe and Orkney Islands, and finally Norway. Weyer also liked to paint and draw, and one of his paintings today hangs in the Admiral's cabin on *Eagle*. The painting depicts the *Horst Wessel* on her way home passing two threatening British cruisers just before the outbreak of war.

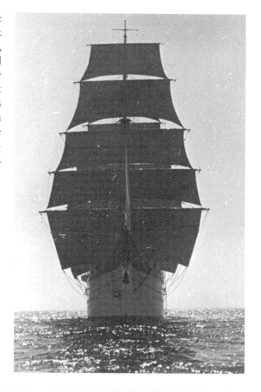

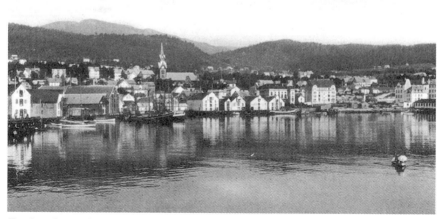

During the cruise to Norway the cadets learned not only about the dangers of a mountainous coast with many fjords and hidden rocks, but they also saw scenes of rare beauty such as the quiet Norwegian town of Molde.

On August 25, 1939, with the clouds of war darkening, *Horst Wessel* returned to Kiel and joined *Albert Leo Schlageter* and *Gorch Fock* at the pier.

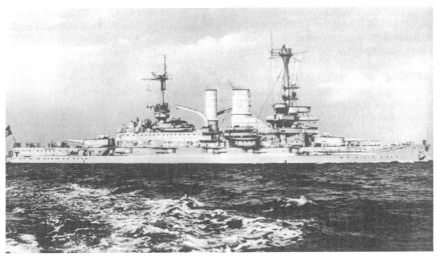

On September 1, 1939, the old battleship *Schleswig-Holstein* opened fire at 4:45 a.m. on Polish positions on the Westerplatte, a Polish enclave in Danzig. For seven days the small Polish garrison held out against German shells and bombs before surrendering. On September 5 the German Navy took all three sail-training ships out of service. Little did their crews know at the time that within four years they would seek shelter from British and American bombs at the very same Westerplatte in Danzig.

V. *Horst Wessel*
1939-45

After the war broke out, at first all three sail-training ships remained in retirement in Kiel. Their sails were stowed away and their masts stood bare into the gray autumn sky of north Germany. In 1940 *Horst Wessel* was put into service again for some training; she also served for a while as a floating headquarters for an Admiral. Then in 1941 she found a new employment.

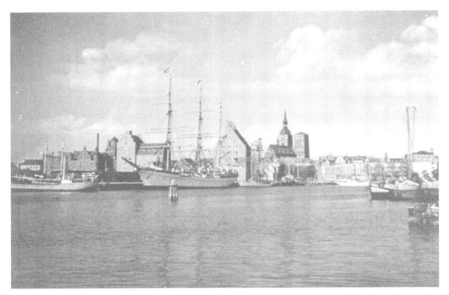

The German Navy moved *Horst Wessel* to the beautiful city of Stralsund on the Baltic Sea and made officers, petty officers, and a crew available to train the Marine Hitler Youth (a special branch of that organization) in sailing and seamanship. Boys could take three-week courses and gain appropriate certification. In return, the Navy retained the right to draft the young men into the Navy. The photo shows *Horst Wessel* at the pier in Stralsund with the old hanseatic city in the background.

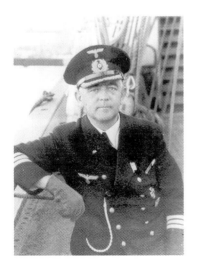

In Stralsund the ship sat at a pier, housed and fed a stream of boys and acted as a floating classroom, while small yachts and boats served for the actual sail-training. Fregattenkapitän Peter Ernst Eiffe, a veteran of the Battle of Jutland, commanded the *Horst Wessel* during the years 1941-42. He was also the author of the humorous book *Spleissen und Knoten* (1926) which found humor in some of the more strange people and happenings of the Imperial Navy.

In late 1942 the navy recommissioned both *Horst Wessel* and *Albert Leo Schlageter* in Kiel. Fregattenkapitän Eiffe was replaced by Kapitänleutnant Schnibbe (pictured above with his dog Peeda), a man with lots of experience on both steamers and sailing ships. Soon young cadets filled the decks and both ships traveled from Kiel further east to Danzig and docked at the historic Westerplatte.

Again the old commands echoed across the decks, young sailors climbed into the rigging, and the sails billowed in the breeze. Together with her sister ship, *Albert Leo Schlageter*, *Horst Wessel* crisscrossed the waters of the Baltic. During the summer both ships went for a visit to the Danish Island of Bornholm.

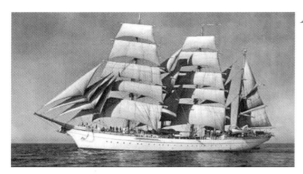

Albert Leo Schlageter

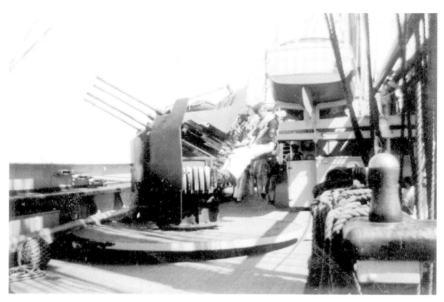

Because of the growing threat from the air, each sail-training ship now carried guns: two single 20-mm guns on the foredeck, two on the bridge, and two 20-mm quads on the waist. Here is a view towards the port foredeck with a quad pointing its barrels upwards. How these guns were to fire rapid salvoes of 20-mm shells without cutting the rigging, nobody knew. While some cadets received training in how to fire the singles, the quads remained the realm of some experienced petty officers.

All the petty officers, by the way, had earned combat medals and became intimately familiar with guns; but about sailing they knew next to nothing. Soon the cadets knew more about the rigging than their immediate superiors.

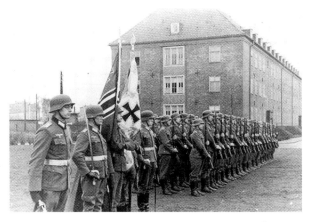

I was one of the men on board the *Horst Wessel* then. I had volunteered for officer training and the navy had called me in October 1943. In basic training we were drilled like Prussian infantry. In early February 1944 I reported, together with 199 others, on board the *Horst Wessel* for six months of shipboard duty. Most of us were very disappointed with our assignment, we had hoped for positions on a destroyer, or cruiser, or some other "front boat;" after all, this was the fourth year of the war.

But we quickly adjusted to life on a sailing ship. We were given permanent sail stations (I landed on the fore lower topsail) and quickly lost our fear of heights. Our group (10 men) had a Bootsmaat (Petty Officer 3rd Class) as the immediate superior, and we had to stand at attention when talking to him. Our lieutenant did everything he could to make our life miserable, and I can truly say that we learned to hate him. But we came to love the ship, the smell of rope and tar, the sea, and the salty language of sailors.

After three months, on April 20, Hitler's birthday, we received our promotion to cadet and could now proudly wear the cadet star on our sleeves. We also began to feel cockier and to enjoy life on board; and the sea rations, while never enough, were a lot better than shore rations.

We also enjoyed our stay in the beautiful old Hanseatic city of Danzig with its many churches and old buildings and streets. Untouched by bombs, Danzig was an oasis of peace in a world at war. We visited theaters, operas, plays, beaches and nearby resorts, and the city had many young ladies eager to meet good-looking young sailors. When we finally left *Horst Wessel* in July, we had become very fond of her. We did not know it at the time, but these months together on board had formed a wonderful bond that would last a lifetime as "Crew X/43" (the Roman numeral for the ten month (October), and the year 1943).

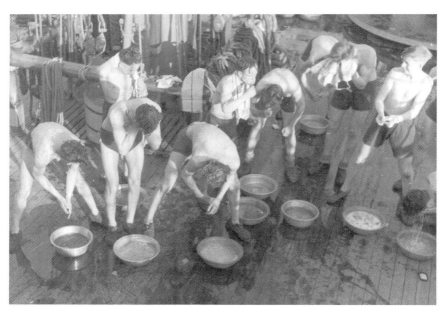

In July 1944 the navy sent a war correspondent, who was also a professional photographer, to take pictures of life on board. The following photos stem from his visit. He started his pictures with the 0600 reveille and with the early morning wash-up on deck in washbasins that the 0400-0600 watch had filled with cold water. This procedure was intended to harden the young cadets and make them less susceptible to a cold. It did work for the most part.

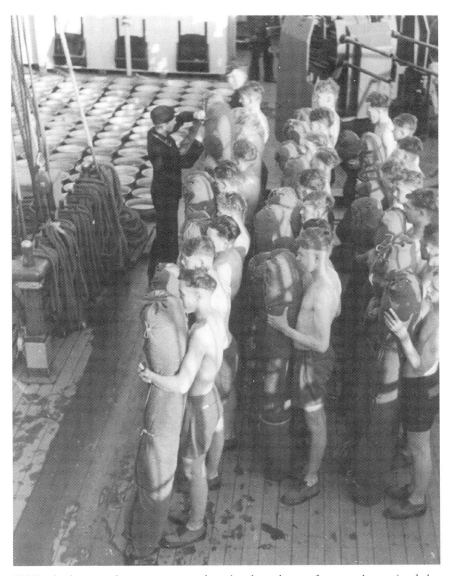

While the hammocks were easy to sleep in, they also, unfortunately, retained the body's odor, especially since they had to spend all day stowed in a hold below. Many times an NCO (non-commissioned officer) would inspect the hammocks to make sure they were tightly rolled and bound. If he could open the hammock, he would send the poor owner back to redo the whole job, a weary and time-consuming procedure. Fortunately these inspections took place only sporadically, and became less frequent with the duration.

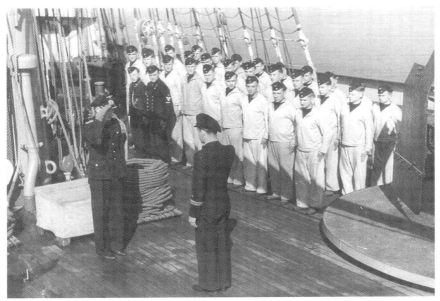

After breakfast the crew assembled on deck for the morning formation. In the above photo the platoon officer reports to his superior. The cadets stand at attention in their daily attire: sail work clothes, dark-blue sweater, sail shoes, and a dark-blue cap. The two men all in blue are the non-commissioned officers (NCOs). Notice the quad gun turret on the right, always in the way.

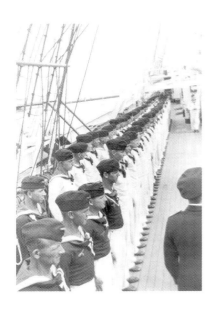

By contrast, sometimes the formal formation might be one of commemoration or to greet some important visitor. In that case the uniform looked more formal: clean white uniforms with collars and blue caps for the men, white pants and blue shirts with collars and blue caps for the NCOs, and all-blue uniforms with white shirts and blue ties for the officers. The deck planks served as the guide to an almost flawless alignment of the crew.

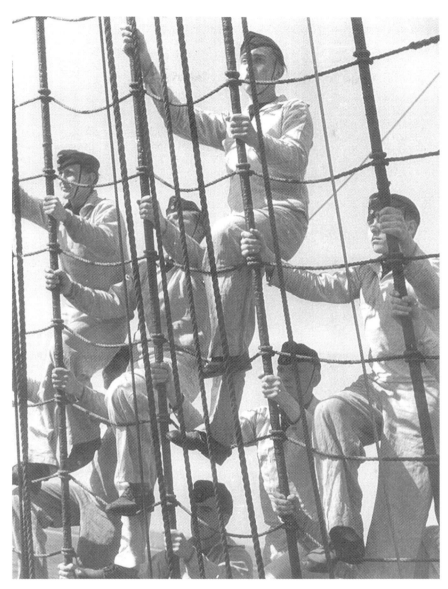

Here we see the cadets going up the ratlines, very close together. The caps are fastened with a band around the chin. The sail shoes are soft and make climbing and working easy yet have enough sole and heel so that they offer a firm support when the men stand on a footrope working on a yardarm. Notice that the men all have learned how to climb: use the shrouds for your hands, the rungs for your feet.

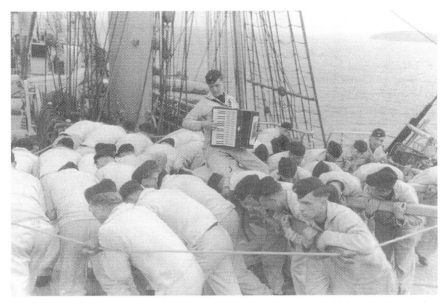

The anchors on port and starboard had long anchor chains, which were easy to let out, but when it came to bringing up an anchor, only the capstan would do it. The capstan, however, needed to be turned, and so the men would insert spill bars and then run around the capstan, thus turning it. Each turn brought the anchor chain up a little bit, each 2½ turns bringing up the chain one meter. Bringing up the anchor remained always a slow and boring business, unless, of course, you could play the accordian. Notice the 20-mm gun in the background.

In July, finally, came the feared "Inspection" by the Admiral of Training, which would put the navy's stamp of approval on the training the cadets had undergone for six months. In the photo above former captain Thiele (foreground), now the Admiral of Training inspects the cadets accompanied by Kapitänleutnant Schnibbe, the new captain (on Thiele's left) and the division officer Oberleutnant Ruoff (on Thiele's right). Notice that the cadets are wearing their scarves over their work uniform, while the NCOs and officers are all wearing class A uniforms.

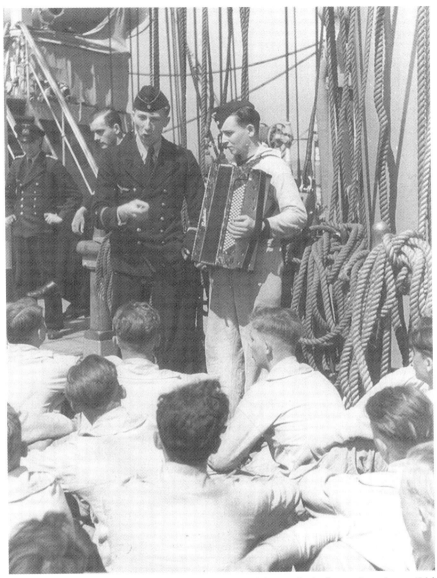

Almost every evening the cadets would assemble on deck for a sing-along. Old shanties, songs of the sea and of Hamburg, some naughty ditties, and some "show tunes" would waft across the evening waves, all belted out by some 200 young voices. For the cadets these minutes meant relaxation and some dreaming of faraway places like Hawaii, Rio de Janeiro, Shanghai, and the South Seas. Here Lieutenant Mayer leads the singing, but usually the cadets had their own leaders.

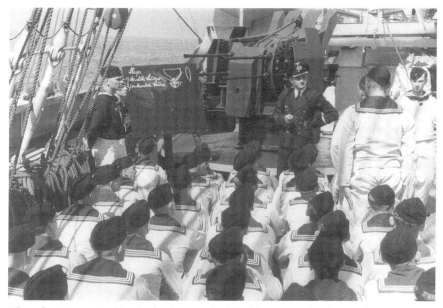

The admiral watched in the background while Lieutenant Streiss conducted a class in sailing maneuvers. When asked to answer a question, a cadet would jump up and stand at attention. Notice Petty Officer Lortzing at ease on the left and the quad 20-mm gun behind the blackboard.

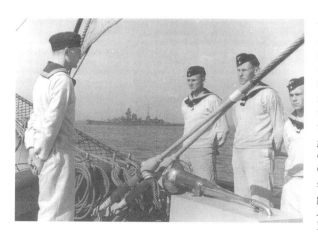

The admiral also wanted to find out what the cadets knew about other topics. Here they stood at the forecastle ready to answer questions or recite certain topics. In the background is the heavy cruiser *Prinz Eugen*, the German Navy's "lucky" ship. She managed to get away when the *Bismarck* had to face the British fleet and she made it through the whole war intact. Following the war the ship was sunk during an atomic test in the Bikini islands.

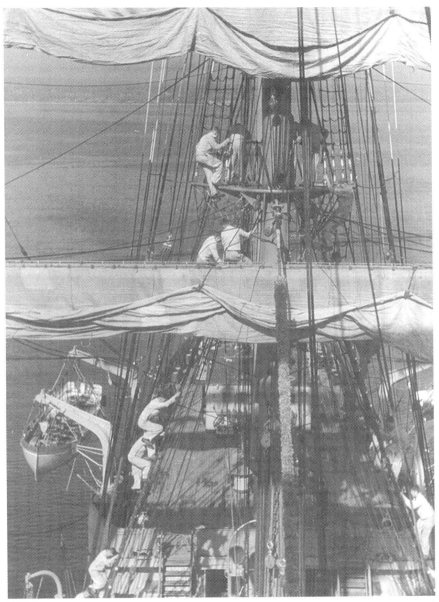

Eventually the inspection centered on the sailing exercises. The cadets manned their sail stations and the sails were set. Soon the big ship moved through the waves of the Baltic. Different maneuvers and several "man overboard" calls gave the admiral a thorough look at the state of training on board the ship.

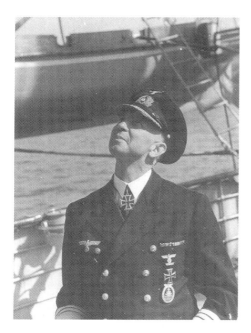

The admiral proved a very critical observer and watched and graded every maneuver very closely. His medals show that he had distinguished himself in combat in several positions. During the inspection he would occasionally show his own prowess; when the talk came to climbing up a free-hanging rope, he climbed up like a young man.

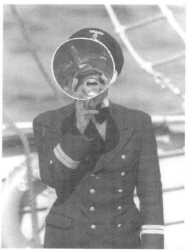

While the admiral was inspecting the cadets, it became increasingly clear, that the officers also felt that they were being inspected. First Officer Freese was constantly using the megaphone (a.k.a. "whisper bag") to shout his commands across the ship and up into the rigging. How far he succeeded in impressing the admiral remains a question, but the volume of his shouting left no doubt as to his intentions. It probably helped him that he had been a Lutheran pastor in civilian life.

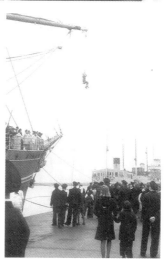

A female visitor being lifted from the pier to the deck of *Horst Wessel* in Danzig in 1944.

While the cadets were sweating through the afternoon's exercises, the photographer had ample time to use his camera to take pictures. The sun lit up sky and water and made for wonderful photos like this one showing the staysails against a silvery sea.

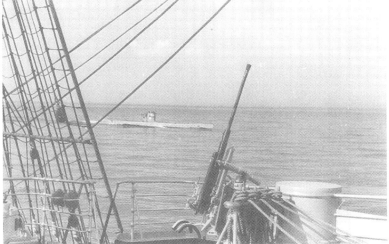

Even in the middle of the war, the Bay of Danzig remained a busy waterway; merchant ships of many nations and military craft plied the water all the time, and every maneuver of *Horst Wessel* always played before a knowledgeable and appreciative audience. The area remained a major training ground for new submarine crews and submarine replacement crews. Here the photographer caught a submarine running past *Horst Wessel* and one of the port side forecastle guns.

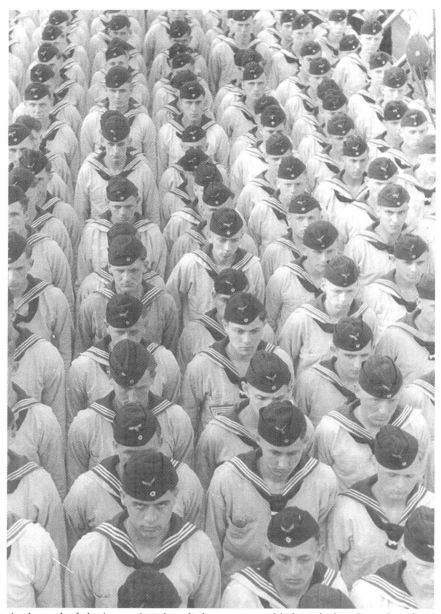

At the end of the inspection the whole crew assembled on deck to hear the admiral's parting words. The photographer here caught a mass of cadets at the farewell address; while most of them kept their eyes forward as ordered, some could not help glancing up at the photographer.

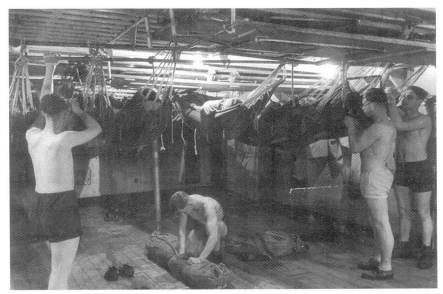

Finally, when the watch piped and called the old "lights out, quiet in the ship, the lanterns are burning!" the tired cadets warily hung up their hammocks and climbed into them for a deep night's sleep. They did not know that the admiral's critique to the captain had disclosed a number of shortcomings and that the promised two-weeks' furlough had just evaporated. This, by the way, was the war correspondent's last photo on board.

Horst Wessel went out sailing for another two weeks. While we cadets were unhappy about the missed furlough, the cruise turned out to be the best we ever had. The weather remained perfect—clear and sunny days with big white clouds cool nights with beautiful stars, always a decent breeze for good sailing, and wonderful anchorages along the Baltic coast. On the last day we even got afternoon coffee with cake—what a way to end our time on board the beautiful lady!

Meanwhile the Allies had landed in Normandy, the Russians were approaching the German border, and German Colonel Claus von Stauffenberg had tried to assassinate Adolf Hitler. All that seemed far away—for a few days.

71

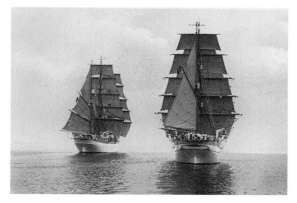

In July 1944, we left for the Academy and another "crew" of cadets came aboard. Because of the danger of air raids and with the Russian armies approaching, both *Horst Wessel* and *Albert Leo Schlageter* moved away from the city of Danzig to an anchorage off the island of Rügen.

On November 14, both ships went on a joint cruise, *Schlageter* leading and *Horst Wessel* about two miles behind. *Schlageter* was scheduled to host a film crew, which was to record the trip, but because of the bad weather the film people stayed on shore. The ships met during the afternoon north of the island of Rügen, set sails and steered east-northeast with the wind coming from southeast. When wind and sea grew stronger and darkness arrived, both ships began to furl sails. At 2040 hours *Albert Leo Schlageter* hit a mine, which exploded underwater on the starboard bow. The explosion caused extensive damage to the hull and the interior, rocked the whole ship, ripped seven cadets from their sail stations on the foresail, and killed a number of the crew in the forward area. Water poured in and soon filled the forward two compartments, and the intact third watertight partition had to be shored up against the growing water pressure. The ship began to list to the bow by more than 10°. After some initial panic, the captain took command and issued orders.

The signalman sent a message to the nearby *Horst Wessel* asking for help. Captain Schnibbe of *Horst Wessel* ordered both small boats into the raging sea in order to take on survivors. He then brought his ship in a daring maneuver so close to the bow of the *Schlageter* that after several attempts the crews could establish a towing connection. For the rest of the night *Horst Wessel* steamed into the wind and the seas keeping *Schlageter* into the wind and preventing her from drifting onto the rocks of a nearby island. In the morning stronger ships arrived and took over the towing duties. During the day *Schlageter* developed a crack on both sides in the hull amidships, extending from the main deck to the waterline, and water began to seep into the ship. The starboard anchor was lost.

When *Albert Leo Schlageter* arrived in port, the carpenter was found still alive in his room. The ship counted 14 dead and 40 wounded. She was hastily fixed up and towed to Kiel for further repairs.

Horst Wessel returned to her anchorage in a bay off the island of Rügen and continued training her cadets.

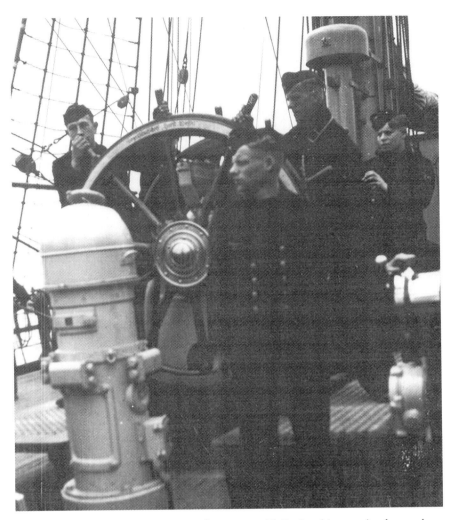

When the last cadets left *Horst Wessel* in January 1945, she ship remained at anchor. In late April, a few days before the end of the war and with the Russian artillery within range, *Horst Wessel* received orders to take some refugees and a company of infantry to safety. Protected by a navy tender, the ship motored undetected across the Baltic. (The photo shows a petty officer with sailors manning the helm and a runner in the foreground.) Rumor on board had the little convoy going to Kiel, but it bypassed Kiel and went to Flensburg Bay on the German-Danish border.

That day a large fleet of Allied bombers attacked the Kiel harbor and caused heavy devastation. Did Captain Schnibbe know?

Amongst the civilian refugees on board was this family from the island of Rügen. The boy, 9 years old at the time, left us a lively account of this trip, a great experience for the children, who had a lot of fun with the crew and the captain's dog.

The following is an excerpt from his account:

"I liked especially the port side of the foredeck... I could look over the railing, and the wind was playing with my hair. Every day was warm spring weather and barely a breeze. I was imagining how 750 horses were pulling the ship—my uncle Willi had explained to me that the machine, which propels the ship, had 750 horsepower.

We were altogether 8 children on board, among them three teenagers. We were the darlings on board of the crew as well as of the soldiers. Every one of them had a friendly word for us, and the captain was especially nice. He gave every child a blue hatband with the golden inscription 'SSS *Horst Wessel.*' He also gave each of us a harmonica, but that turned out to be a mistake, because the children immediately ran through the decks producing a gruesome concert on their new toys. But our mothers quickly solved that problem—they just took the harmonicas from us."

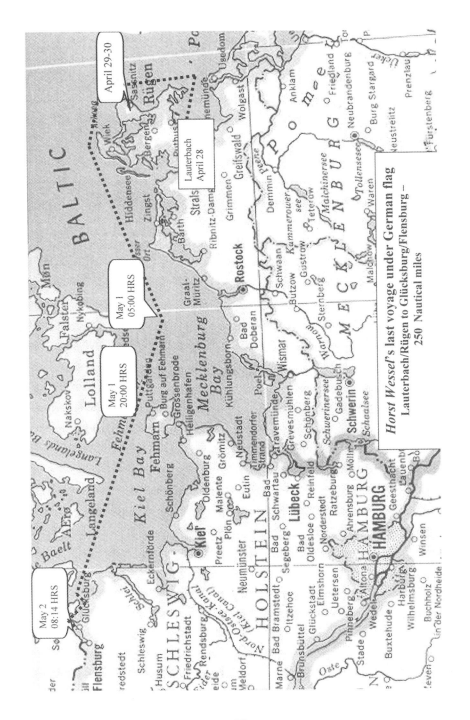

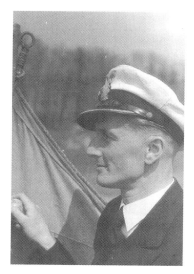

In Flensburg, the captain had to surrender the ship and all arms to the British, and thereafter the ship had to fly the Union Jack.

The British now ordered Kapitänleutnant Schnibbe to bring the ship first to Kiel, then to Wilhelmshaven, where she spent the rest of 1945. In early December she was ordered to Bremerhaven, where a decision would be made among the victors about her future. The victors had claims to all ships of the German Navy and Merchant Marine, and sail-training ships like *Horst Wessel* and *Schlageter* presented prime prizes. *Albert Leo Schlageter* had been repaired and had made it to safety; the *Gorch Fock* had been scuttled near Stralsund, where the Russians made plans to raise her; and the *Herbert Norkus* remained unfinished.

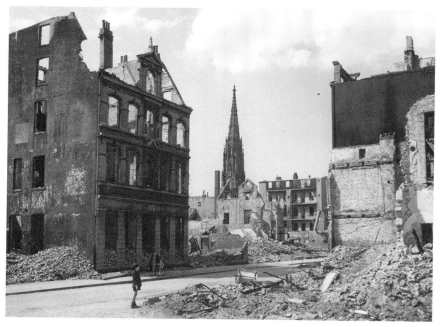

Bremerhaven, a major port on the North Sea and an easy target for Allied bombers for years, lay in ruins. After the end of World War II, the city became an American enclave in the British Zone of occupation and a major supply and replacement depot for the American Forces in Germany. Bremerhaven soon bustled with troops and sailors.

Meanwhile, *Horst Wessel* had found a temporary pier here. Only a skeleton crew still remained on board, much of the equipment had been stored somewhere or disappeared, and her bare masts were towering into the skies. The ship was waiting for a new master.

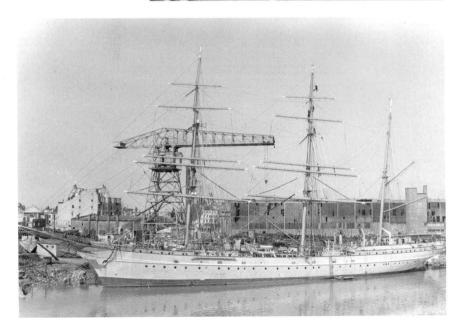

With the end of World War II the Allies disarmed and dissolved the German Armed Forces including the navy. All personnel ended up behind barbed wire. All naval vessels and property came under the jurisdiction of the victors for their disposal, and only a small fleet of German minesweepers continued to operate under British supervision.

The victors awarded the eastern German provinces of Silesia, East Prussia, West Prussia, and Pommerania—fully one third of the former Germany—to Poland; a small sliver of East Prussia went to the Soviet Union. In addition, Poland—on her own—occupied and incorporated the port city of Stettin. With these transfers, Germany had lost almost one half of her former shoreline with the old port cities of Königsberg, Elbing, Danzig, and Stettin. As a result of these transfers about 16 million Germans lost their homes; those who had not fled were brutally expelled.

During the Nuremberg War Crimes Trials the German Navy was not implicated in the major crimes of the Hitler regime. Both Admirals Raeder and Dönitz were accused of participating in wars of aggression and were sentenced to 20 years in prison. Charges against the German U-Boat methods of warfare were dropped when the defense showed that the U.S. submarines had operated using the similar tactics.

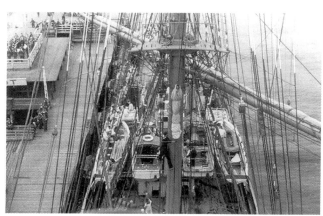

Horst Wessel in Danzig in 1944, showing two life-saving boats, and two motor boats (one the "Captain's boat," and the other the "work boat)."

VI. *Horst Wessel* to *Eagle*

Much has been said about the circumstances surrounding the delivery of *Horst Wessel* to the Unites States. The U.S. Coast Guard Academy Alumni Association *Bulletin* carried an article by Captain Harold B. Roberts, class of 1931, in which he quotes the story as told by Commander Robert Canby, Sr., U.S. Naval Reserve. The U.S. Navy sent Canby to Frankfurt, Germany, at the end of the war to set up headquarters for Vice Admiral Robert Ghormley (Commander of U.S. Forces in Germany). Because of his knowledge of Russian and ships, Canby went to Berlin as a member of the Tripartite Commission for the division of the German fleet, and ended up in the subcommittee handling the sail-training ships, *Horst Wessel*, *Albert Leo Schlageter*, and two merchant ships. After inspecting the ships, the subcommittee met in Berlin, Captain Graubart of the U.S. Navy was the presiding chairman for the month. The following is quoted from Canby's story:

"It was decided that the ships be divided into three lots for division purposes. The lots were numbered:

> 1. for *Horst Wessel*;
> 2. for *Albert Leo Schlageter*; and
> 3. for the two merchant sail-training ships.[1]

Three small pieces of cardboard were made with these numbers and placed in Canby's cap on the table. The moment of drawing arrived! Canby drew #3, the Russian Commodore #1, and Lieutenant Commander Watkins drew #2 for the British! Immediately, Canby turned to the Russian Commodore and gave him a quick sales talk on the superior advantages of two large ships for his BIG COUNTRY with many people to train. 'Are you sure they are O.K.,' he was asked? Canby reiterated that the Commodore could certainly depend on both since he had actually seen and inspected them. The Russian was convinced and the pieces of cardboard were quickly exchanged under the table.

LCDR Watkins excitedly shouted, 'Hey, Canby, what's going on? What's the delay?' At this time the diplomatic action of the Chairman, Captain Graubart, banging the gavel on the table and asking, 'Well, gentlemen, what did you draw?' brought everyone's attention to him. Canby, in all innocence, simply stated, 'I drew Number One, Sir!' The official meeting closed, and the *Horst Wessel* was ours!"

[1] Probably the *Padua* (*Kruzenstern*) and *Kommodore Johnson*, ex *Magdalene Vinnen* (*Sedov*).

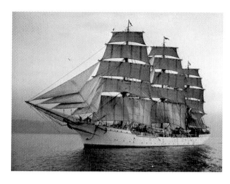

The U.S. Coast Guard has always used sail-training as an essential tool in the education of its officers.

The service's first school of instruction was founded on board the Revenue Cutter *Dobbin*. Later the cutter *Chase* was used to train cadets. When established in New London, the Coast Guard Academy has always had a sail-training ship attached to it.

When Denmark was overrun by the Germans in 1941, her training ship *Danmark* happened to be visiting Jacksonville, Florida. The commandant of the Coast Guard offered to charter the vessel as a training ship for the Academy in New London, and so the *Danmark* spent the World War II training future Coast Guard officers and teaching officers about sailing a tall ship. One of these officers was Commander Gordon P. McGowan.

After the war the United States ended up receiving *Horst Wessel* and *Albert Leo Schlageter* as war prizes; *Schlageter* had suffered mine damage, but *Horst Wessel* had escaped unharmed. The U.S. Coast Guard under the direction of Rear Admiral James Pine, Superintendent of the Coast Guard Academy, immediately applied for the *Horst Wessel* and received permission to take possession of the ship. The U.S. Navy declined the use of the *Schlageter* and in 1948 sold her to Brazil for the symbolic sum of $5,000. *Albert Leo Schlageter* would become the *Guanabara*, and, in 1962, was sold to Portugal and renamed *Sagres*.[1]

Captain Gordon McGowan, born 1904 in Mississippi, enlisted in the U.S. Coast Guard in 1924. He served in several ships and received promotion to Commander in 1942 and assignment to the Academy as head of the seamanship department. In January 1946, the Coast Guard sent him to Bremerhaven to outfit and commission *Horst Wessel*. McGowan became the first captain of *Eagle*, heading a long list of distinguished Coast Guard commanding officers.

[1] *Gorch Fock* was claimed by the Soviet Union as was the *Mircea*, which was later returned to Romania.

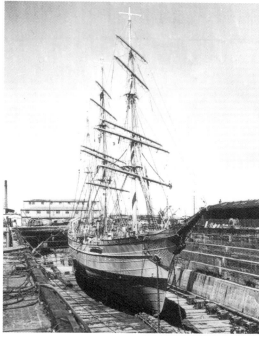

With much of Bremerhaven in ruins, McGowan had to scrounge and deal to get the vessel repaired and equipped, but by spring 1946 the ship was getting into shape. He later described his experiences, adventures, and new friendships in his book, *The Skipper and The Eagle.*

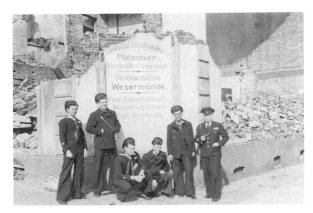

McGowan assembled a staff and crew of U.S. Coast Guard personnel and also retained most of the German staff including Kapitänleutnant Schnibbe. Yet McGowan did not have sufficient men trained in handling a tall ship across the Atlantic. To remedy this he sent out a call for German volunteers with tall ship experience.

Good food, love of the sea, and the lure of America brought a response. Some 40 Germans volunteered, almost all of them former cadets of the 1944 Segelschulschiff *Horst Wessel*. This photo caught some of them before going on board their old ship. Some arrived in civilian clothes, some in navy uniforms. On the far left we see the cook, then two petty officers; the rest are former cadets.

On May 15, 1946, Captain McGowan read his orders to the assembled crew of Americans and Germans and announced that henceforth the ship would be named U. S. Coast Guard Cutter *Eagle.*

Kapitänleutnant Schnibbe, the German skeleton crew, and the additional volunteers stood at attention when the ship was renamed; many Germans had tears in their eyes.

Captain Gordon McGowan's Book *The Skipper and The Eagle*, with a foreword by Alan Villiers, was published in 1960. It was subtitled: "How a Coast Guard officer made a German prize of war into a United States ship at the end of World War II, and sailed it home through trade winds and a hurricane."

Eagle was the seventh vessel to bear that name in the history of the U.S. Coast Guard. The first operated out of Georgia during the early days of the Revenue Marine and was removed from service in 1798. The second was launched in 1798 and saw service in the Quasi-War with France. The third *Eagle*, a schooner, operated on Long Island Sound between 1809-14. Her heroic exploits in the War of 1812 were forever marked in the Coast Guard service song "Semper Paratus." A fourth and fifth *Eagle* served the Revenue Marine from 1815 to 1830. The sixth *Eagle* was a 100-foot cutter launched in 1925 to fight the Rum War.

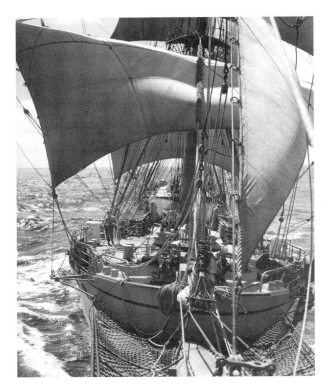

The new *Eagle* left Bremerhaven in June 1946, motored past the minefields of the North Sea, and after a stop in England, resumed her voyage, finally getting under sail.

On this leg Captain McGowan discovered that the ship handled extremely well and that she reacted to all commands like "a perfect lady."

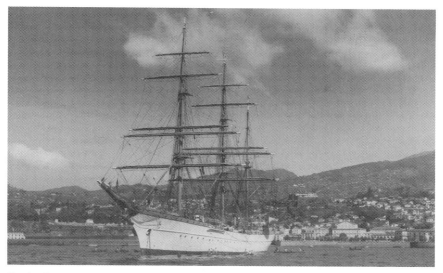

In the Portugese island of Madeira, famous for the wine, Americans were permitted ashore, but the Germans were not allowed off the ship. Some Germans swam ashore anyway and had a night on the town.

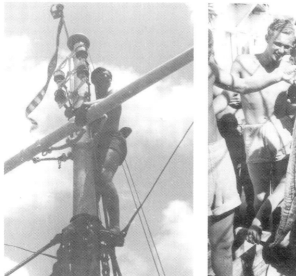

The relations between Americans and Germans remained good throughout the trip, and the Coast Guard sailors learned quickly from the German crew members.

On the last leg of the trip, between Bermuda and New York, *Eagle* ran into an unexpected and very strong hurricane and into imminent danger, but Captain McGowan showed excellent seamanship and leadership and made some dramatic decisions.

The ship proved her seaworthiness, balance, and steadfastness and survived the storm, alas with many of her sails torn and ripped.

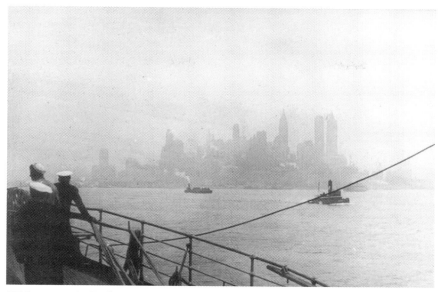

With torn sails *Eagle* staggered into New York. During the night an FBI boat circled around *Eagle* to make sure no Germans jumped ship. The next morning *Eagle* motored up the Hudson to Orangeburg and unceremoniously let off the Germans, who ended up in Camp Shanks, a prisoner-of-war camp. *Eagle* went on to New London, Connecticut, for repairs and outfitting.

In July 1946 the U.S. Coast Guard welcomed their new sail-training ship *Eagle* in New London, where she found a permanent home at the U.S.C.G. Academy. Within weeks *Eagle*, with bright-eyed Coast Guard cadets on board, made a trip to Martha's Vineyard and Nantucket. In early August the German volunteers arrived back home in Bremerhaven.

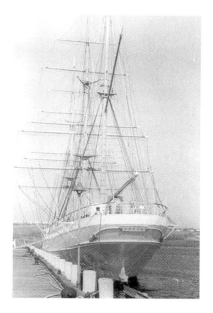

After his *Eagle* assignment the Coast Guard sent Captain McGowan on an urgent mission to Korea; his successor in 1947 was Captain Miles Imlay.

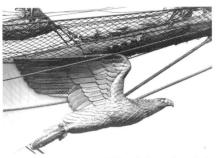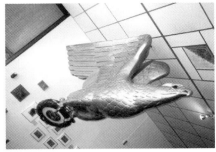

The original *Horst Wessel* figurehead (left). The plate the eagle is holding in its talons used to be emblazoned with a swastika. When the U.S. Coast Guard acquired the ship, it replaced the swastika with the Coast Guard shield. That same figurehead is today located in the museum at Waesche Hall at the U.S. Coast Guard Academy.

Eagle Figurehead

The original German figurehead remained on *Eagle* until 1952. That year the German figurehead was replaced by the smaller figurehead from an early (1877) Academy training bark *Salmon Chase*. The original figurehead was, for a time, placed on display at Mystic Seaport Museum in Mystic, Connecticut; it was removed in 1965. In 1956 trailboards were added and *Eagle* kept this combination until she was involved in a collision in 1967 near Baltimore harbor. The figurehead was down in the mess deck at the time and was not damaged. The *Chase*'s figurehead remained on *Eagle* until 1971 (the trailboards were removed following the 1967 accident) when it was replaced by a fiberglass copy of the original German figurehead. The fiberglass figurehead was severely damaged in storms in 1972 and 1974, and was replaced in 1976.

The figurehead from the *Salmon Chase* (left). Original figurehead on display at Mystic Seaport, Mystic, Connecticut (right).

VII. *Eagle*
1947-75 - Summer Cruises

During the years 1947-75 the U.S. Coast Guard Cutter *Eagle* followed a fairly consistent schedule of summer cruises. She would be commissioned in the spring, then decommissioned in the fall and laid up for the winter. Her Commanding Officer would be assigned each summer, and as a rule it was a member of the Academy staff. Until 1963, *Eagle* would take summer-long cruises to Europe in the company of other Coast Guard vessels as part of a Cadet Practice Squadron, and after 1963, *Eagle* took mainly shorter summer cruises to North American ports (see Cruises in the Appendix). Maintenance was performed by the skeleton crew in the winter, by cadet work parties, and by the Coast Guard shipyard in the fall.

In August 1947, *Eagle* visited New York City for the first time as a training ship. Here are some impressions by Jack Shanley of *The New York Times*:

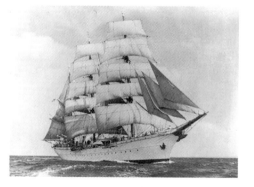

"She carried 17 officers, 58 enlisted men, and 102 first- and third-year cadets of the Coast Guard Academy.

The *Eagle* is a craft to gladden the hearts of windjammer historians. She carries twenty-three sails. Beneath her bowsprit she bears proudly an ornate gold-plated eagle. It was installed by her Nazi builders, but the stigma of the swastika that once was part of the figurehead has been replaced by the SEMPER PARATUS shield of the Coast Guard.

On her engine revolution indicator remain the German-language legends "Zurück" and "Voraus ("Astern" and "Ahead"). On the rudder angle indicator are the terms "Steuerbord" and "Backbord" ("Starboard" and "Port"). In some

respects *Eagle* is a primitive vessel. She carries no power winches. The weighing and dropping of her anchor and other heavy tasks involve manual labor.

The ship's company turns to with painful regularity when her sails, measuring a total of 21,350 square feet, are spread. She uses her auxiliary Diesel engine only occasionally. The rigging is a maze that confounds seafarers on power vessels as much as it does the layman. It is measured in miles, according to one of the ship's officers.

But the *Eagle* has been equipped with radar, loran and other electronic devices.

The Coast Guard Cutter *Campbell* accompanied the *Eagle* on the cruise and arrived here with her. The two ships comprise a cadet practice squadron.

Captain Miles H. Imlay, head of the Department of Aviation, Navigation and Seamanship at the Coast Guard Academy, commands the *Eagle*. Commander O.C. Rohnke commands the *Campbell*."

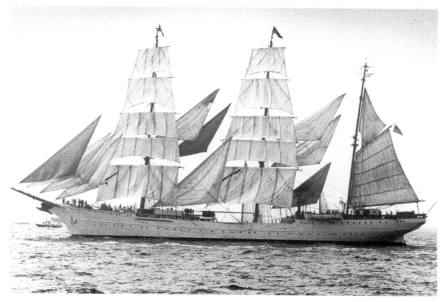

In the early 1950s, *Eagle*'s looks changed—just a little. As the story goes, it was Captain Carl B. Bowman, captain of *Eagle* from 1950 to 1954, who replaced the split spanker with a single spanker because he thought it looked "too Germanic." *Eagle* would carry this new look for several decades. During his Australia trip Captain Ernst Cummings realized that a split spanker would give the ship much more flexibility and and proposed it. In 1991 Captain David V. V. Wood had it reinstalled.

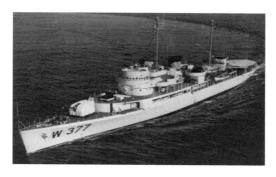

In 1953 a Cadet Practice Squadron consisting of *Eagle* and the 311-foot cutter *Rockaway* (W-377) undertook a long cruise to Oslo, Norway, Antwerp, Belgium, La Coruna, Spain and Las Palmas, Canary Islands, from June 7 to August 25th. During the cruise, the squadron commander Rear Admiral Arthur G. Hall resided on board *Eagle*, while the deputy squadron commander resided on board *Rockaway*. A third of the cadets were on board *Rockaway* at all times and rotated at each port of call.

On September 20, 1952 President Harry Truman, accompanied by Mr. John W. Snyder, Secretary of the Treasury, and Vice Admiral Merlin O'Neill, Commandant of the Coast Guard, visited the Coast Guard Academy, where the corps of cadets greeted him with 21-gun salute. After a speech stressing the value and importance of leadership, the president visited the grounds of the Academy. On the parade ground the president was greeted by Connecticut Governor John Davis Lodge, Rear Admiral A.G. Hall, Superintendent of the Academy, and Mayor Moses A. Savin of New London. Then the cadets passed in review. Mr. Truman also visited *Eagle*, where he posed for the above picture at the wheel.

Early in 1954 a German exchange student visited *Eagle* at the Coast Guard Academy in New London. Wolfgang A. Betzler, a former German naval cadet who served on the ship in 1944 and was studying in New York City, decided to visit his old ship again. Here he is shown chatting with Commander Albert F. Wayne, Executive Officer, and cadet John W. Raffensperger.

In 1955 renowned mariner and writer Alan Villiers sailed aboard *Eagle* and wrote the article "Under Canvas in the Atomic Age" for the July 1955 *National Geographic* magazine.

Villiers also wrote the book *Sailing Eagle: The Story of the Coast Guard's Square-Rigger* (Charles Scribner's & Sons, 1955).

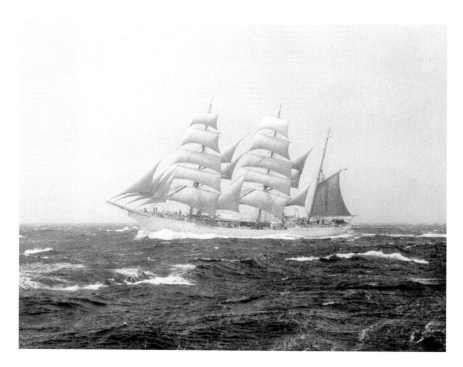

On *Eagle*'s visit to England in 1957, His Royal Highness Prince Philip, Duke of Edinburgh, came aboard and visited with the crew. After years of distinguished service in Britain's Royal Navy, he reluctantly gave up his career when his wife, the Princess Elizabeth, assumed the throne as Queen Elizabeth II in 1952, and he became the Queen Consort.

Ben Sharpsteen (1895-1980) spent his life in the movie business and created great features such as "Walt Disney Presents," and also memorable films such as "The Vanishing Prairie," "The Living Desert," and "Alice in Wonderland." In 1959 he produced "Cruise of the *Eagle*" for Walt Disney. Photographed in Cinemascope, the film became a huge success. For this film *Eagle* sailed from New London to San Juan, Puerto Rico, to the Panama Canal, to Havana, Cuba, Halifax, Nova Scotia, Newfoundland, Boston and back to New London.

In 1959, off Cape Cod, Massachusetts, Second Class cadet Mike Greeley fell to his death. He was going up the backstay to the main mast—as was permitted in those days —and just as he reached the footrope at the mast, he lost his hold and fell to the deck.

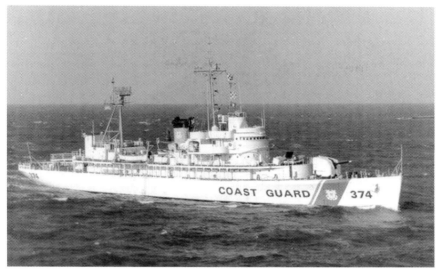

Rear Admiral Stephen Evans, recently appointed Academy superintendent, announced on April 2, 1960, that he would be squadron commander of the annual cadet practice cruise which would take *Eagle* and the cutters *Absecon* (W-374) and *Yukatat* across the Atlantic to England and France on a 51-day, 7,881-mile cruise beginning on June 11, 1960.

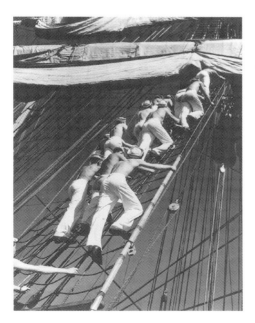

During the 1960s, Coast Guard cadets of the first and third classes would leave the Academy to board *Eagle* for a 2½ months cruise, generally on the North Atlantic. During such a cruise the new Coast Guard cadets faced the same challenges as many others before them: to go up into the rigging, overcome the fear of heights, and learn to handle the sails in sunny weather and also in a storm. Going aloft for the first time remains a major experience for most cadets, and for many a cadet a scary moment.

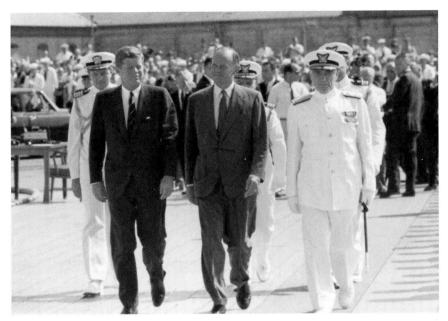

President John F. Kennedy visited *Eagle* on August 15, 1962 during the training barque's first port-of-call at Washington, D.C. Escorting the president is Secretary of the Treasury Douglas Dillon and Coast Guard Commandant Edwin J. Roland.

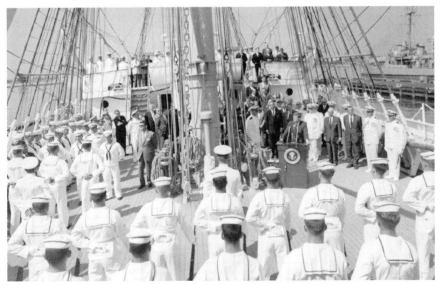

President Kennedy addressing cadets while *Eagle* is at the Washington Navy Yard.

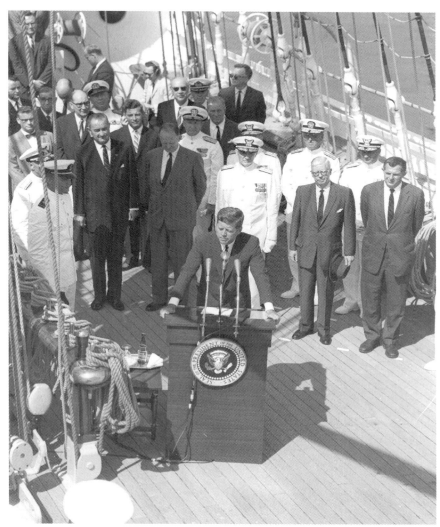

Dignitaries seen in first row behind the president (left to right) are Vice President Lyndon B. Johnson, Secretary of the Treasury Douglas Dillon, Commandant of the U.S. Coast Guard Admiral Edwin J. Roland, Under-Secretary of the Treasury Henry Fowler, and Assistant Secretary of the Treasury James A. Reed.

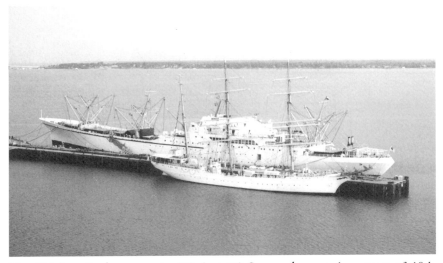

The 295-foot *Eagle* next to the 600-foot NS *Savannah*—a stark contrast of 19th century seamanship with 20th century atomic power. Built in 1962 as a showcase for President Dwight D. Eisenhower's "Atoms for Peace" initiative, the nuclear-powered merchant ship *Savannah* was developed to demonstrate the peaceful and commercial application of nuclear power, and to open ports throughout the world to visits from nuclear-powered vessels. She performed well, at sea, had a perfect safety record, and her fuel economy was unsurpassed. She was deemed a commercial failure, however, and was pulled from service in 1969.

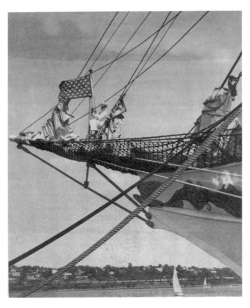

Seaman Dannis Barrett of Coca, Florida, hoisted the jackstaff during commissioning ceremonies for the U.S. Coast Guard Cutter *Eagle* on June 5, 1963. Under the command of Captain William K. Earle, Head, Professional Studies Department at the Academy, *Eagle* joined the Coast Guard's fleet in preparation for her annual cadet practice cruise. Note the small figurehead and trailboards.

During 1964, 12 Major sail ships and 11 smaller schooners ran a transatlantic race from Lisbon, Portugal to Bermuda under the auspices of Britain's Sail-Training Association. Following the race the ships sailed the 697-mile trip to New York City under "Operation Sail" from July 10-19 for the "grandest massing of tall wind-powered ships ever seen in history." *Eagle* joined the tall ships in Bermuda.

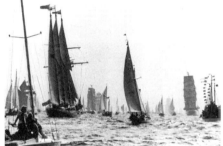

Shortly before noon on Friday, January 27, 1967, *Eagle,* under the command of Commander Richard S. Dolliver, left the Coast Guard Yard at Curtis Bay, Maryland for the trip back to New London with a crew of six officers and 30 enlisted men. After traveling down the Patapsco River the ship headed into the Craighill Channel. Dense fog was developing.

Meanwhile the Philippine freighter M/V *Philippine Jose Abad Santos*, with a pilot aboard, was steaming upriver towards Baltimore. A 10,000-ton steamer built 1960, 513 feet long and 64 feet wide, she proceeded at about 13 knots, and at noon her watch officer recorded "foggy, zero visibility" in the log. *Eagle* was motoring downriver at about 6 knots.

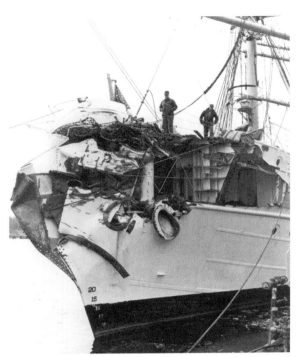

Shortly after 1330 hours, in zero visibility, the lookouts on both *Eagle* and the M/V *Philippine Jose Abad Santos* spotted the other ship on a collision course maybe 200-300 feet ahead. Last-minute commands to the engine rooms could not stop the ships in time, and the vessels collided almost bow-to-bow shortly before 2 p.m. There were no personnel injuries on either vessel. The freighter received only minor damage and her captain, after inquiring if *Eagle* needed help, proceeded to Baltimore for repairs.

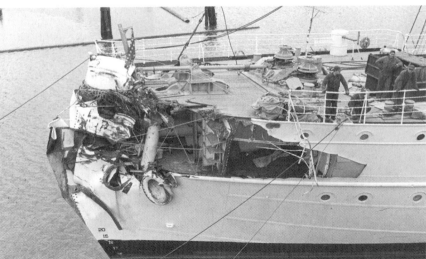

Eagle, however, sustained major damage to her bow and foremast. The crew maneuvered to pick up her bowsprit, secured it to the port side of the hull, and returned the ship to the Coast Guard Yard. *Eagle's* port anchor was carried away and was lost.

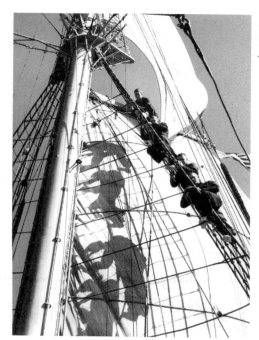

Eagle was repaired in time for her summer cruise to Quebec, New Jersey, Providence, and Nantucket.

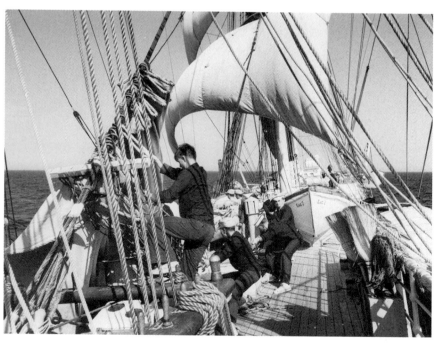

On July 21, 1969 *Eagle* found herself docked at the South Street Seaport in New York City, while at the same time another vessel, the U.S. Spacecraft Eagle, was about to land on the moon. Even while many visitors were coming aboard Barque *Eagle*, the crew eagerly listened to the radio. Eventually the crew proposed to Captain H. A. Paulsen that the ship send a congratulatory message to the "the other Eagle." Later some of the crew checked into hotels to watch the lunar happenings on television.

In 1972, the Gold Star Bridge over the Thames River in New London, Connecticut, had a span under construction and safety nets were slung under the bridge. *Eagle* has to pass under this bridge on the way to and from the Academy and normally—even with lowered mast-tops—has only two feet of clearance. Even though the safety nets had been triced up, on this June day *Eagle* snagged one of the nets and the upper masts were bent double. No one was injured, and the nearby Electric Boat Shipyard was good enough to repair the masts in time for *Eagle*'s planned trip to Europe.

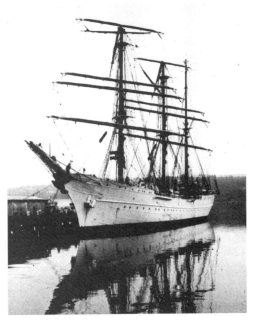

Starting in 1972, the Coast Guard began to change over the service's uniforms from those that were modifications of the U.S. Navy, to a distinctive look that solidified the fact that the Coast Guard was a separate organization. The new uniforms, affectionately called "Bender Blues" in honor of Commandant Chester R. Bender, were officially adopted in 1975.

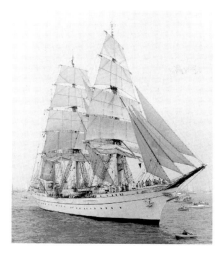

In 1972, President Nixon acceded to the request of West Germany's Chancellor Willy Brandt and ordered the Coast Guard to send *Eagle* to West Germany in order to take part in the sail festivities surrounding the Olympic games. It would be the first time that *Eagle* would sail to Europe without an escort.

In an article published in 1974 in the U.S. Naval Institute's *Proceedings* entitled "Tall Ships and Sailormen: Operation Sail 1972," Lieutenant Commanders David V. V. Wood and Kenneth W. Thompson recall:

Numerous changes to the Eagle's *normal summer routine would be necessary in order to make the voyage. But regardless of certain disadvantages, it was decided that one tradition must be upheld: cadet training must be the primary mission. The* Eagle *would continue to be, insofar as possible, a cadet-operated ship. She would be manned by her normal summer complement of 12 officers and 50 enlisted men, plus some 100 cadets of the Academy's second class. These 100 cadets would run the ship, for on the* Eagle, *all billets, from OOD (Officer of the Deck) to lookout, EOW (Engineer of the Watch) to oiler, and MAA (Master at Arms) to mess cook, are filled by cadets on a rotating basis to provide them with exposure to a full range of shipboard duties. Officers and petty officers stand watches as instructors and safety observers, but leave the actual duties and responsibilities to the cadets as much as safe operation will allow. Equipment maintenance and repairs, cooking, and administrative functions are the only areas in which cadets are not routinely involved. The actual sailing of the ship is done exclusively by cadets, with a minimum of officer and enlisted supervision, and all sail handling is done by "Norwegian steam," with no mechanical assistance other than blocks and tackle.*

Actually two separated but related events were planned: a "Tall Ships Race" for sail training ships from all over the world, and "Operation Sail", an in-port gathering of these ships, preceded by a nautical parade... in Kiel, the site of then Olympic Yacht Races.

The article goes on discussing various aspects of this visit, then says:

In 1946, the Eagle *had departed Germany under Coast Guard command. In 26 years she had never revisited Germany, even though she had made frequent training cruises to Europe between 1946 and 1963. To the Germans, therefore, a visit by the* Eagle *had all the appeal of a homecoming. Even more attractive was the prospect of a scratch race between the* Eagle *and the Federal German Navy's* Gorch Fock II, *a bark built to the same plans as the* Eagle *and commissioned in 1958 as a training ship for German naval cadets... it was to be a command performance.*

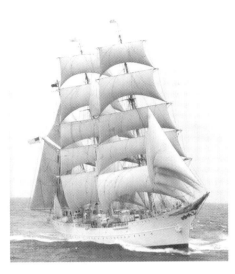

On July 24 *Eagle* left for Europe. After a few days, driven by strong and favorable winds, the ship won the Boston Teapot Trophy for the 1,104 miles covered in a 124-hour period. After many days of sail exercises *Eagle* reached the Isle of Wight and dropped anchor close to the German *Gorch Fock II*. In the evening the Americans were invited to the German ship. Wood and Thompson described it:

"...Language barriers, different customs, past wars—none of these matter in the slightest. Instead we sing shanties, swap nautical terminology, tell sea stories, and talk of ourselves. Amid the laughter, the boasting, and the good German beer, there grows a feeling which will never be forgotten. At the end of the evening we know that, whoever may win the race, the chance to have been here and experience the true comradeship of sailors is a large part of what we have come for."

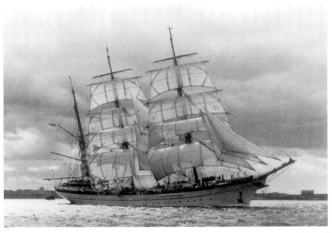

The race itself took the *Dar Pomorza* (Poland), the *Gorch Fock II*, and *Eagle* from the British Channel to the Baltic through storms and constantly changing winds and lasted from August 16 to 21. Most of the way *Eagle* gave the *Gorch Fock* a good run for the money, but then, after three days, suddenly several sails on *Eagle* ripped and had to be taken down and repaired. With this handicap, *Eagle* lost the race, but crew and captain were exhilarated from a tough and exciting race and proud of their performance.

INTERNATIONAL SAIL TRAINING RACES 1972

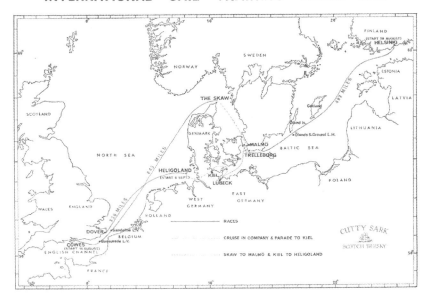

Arriving in Kiel *Eagle* ended up on the famous Blücher Bridge where she used to dock as *Horst Wessel*. Her neighbors now were West Germany's new *Gorch Fock II* (built in 1958), Norway's *Statsraad Lehmkuhl* and *Christian Radich*, and Columbia's *Gloria* among others. One of the visitors was Admiral August Thiele (Ret.), who had been the first captain of the *Horst Wessel* in 1936. He was shown through the ship and complemented the captain and the crew on the nice condition of the ship.

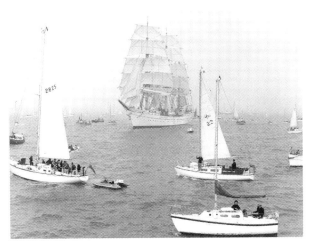

When Palestinian terrorists killed several Israeli Olympic athletes at the Munich airport, the Kiel festivities ended and the tall ships silently made their way home.

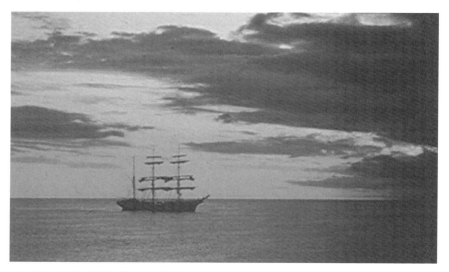

On March 21, 1791, George Washington commissioned Hopley Yeaton, born near Portsmouth, New Hampshire, in 1739, as the first officer in the U.S. Revenue Marine Service, the forerunner of today's Coast Guard. Captain Yeaton's insistence on a school for the training of young men ultimately led to the establishment of the U.S. Coast Guard Academy, where Yeaton Hall is named in his honor.

Reminiscent of the USS *Brooklyn* carrying the body of John Paul Jones from France to the U.S. Naval Academy in 1905, *Eagle,* in August 1975, picked up the casket of Hopley Yeaton from the cemetery in North Lubec, Maine, and carried it to New London. After a service at the Academy Chapel, Captain Yeaton's remains were laid to a final rest in a crypt near the Academy Chapel on October 19, 1975.

VIII. *Eagle* 1976-87:
The Big Make-Over

The years 1976 through 1987 brought major changes to Barque *Eagle*. First of all her exterior changed. She assumed the same stripes on the hull that all cutters of the U.S. Coast Guard carried and that identify them as vessels of the Coast Guard. Then the Coast Guard replaced old figurehead eagle with a shiny new eagle. Another surprise was the inclusion of women in the Coast Guard cadet corps and their appearance on board. For this the living and sleeping quarters had undergone a major change, as the old hammocks disappeared and smaller compartments with bunks replaced them. A new pilot house was cleverly built into the superstructure so as not to spoil her lines. Beyond all this, the "lady" received a major physical refurbishing, including replacement of the original teak deck and all the remaining original German machinery, and new procedures brought the ship in line with the standards of the U.S. Coast Guard. And beginning with incoming Captain Paul Welling in 1976, *Eagle* would now have a permanent, year-round commanding officer.

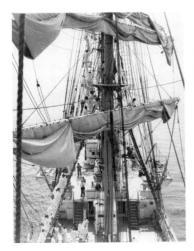

At left, looking aft aboard *Eagle* prior to her pilot house. Above, with pilot house, installed in 1976.

107

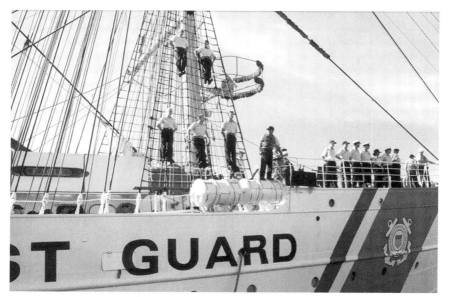

On March 12, 1976 *Eagle* arrived in New London from a refurbishing at the Coast Guard Yard in Curtis Bay, Maryland, sporting the blue and orange racing stripes on its white bow and the words "Coast Guard" on its hull. These markings, identical to those carried by other Coast Guard vessels, would make *Eagle* readily identifiable at the upcoming Tall Ship Parade in New York on the occasion of the Bicentennial Celebration. The stripes became the subject of great controversy between those who approved and those who did not.

Eagle also arrived with a new figurehead. Rockport, Massachusetts, artist/woodcarver Robert Lee Perry fashioned the new eagle from Honduran mahogany, which was then covered with more than $2,000 worth of gold leaf. With a wingspan of six feet and a length of 13 feet the new eagle replaced the old fiberglass eagle. The Bicentennial budget covered the creation of the new figurehead.

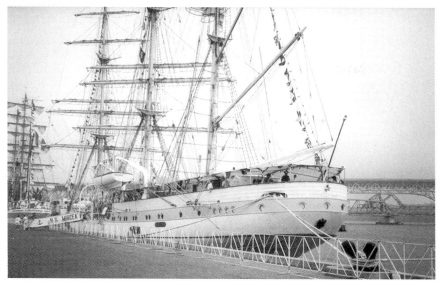

On June 20 *Eagle* narrowly missed several collisions at the beginning of the Bicentennial Race from Bermuda to Newport, Rhode Island. About 80 smaller vessels and 11 tall ships were massing behind the 1.25 mile starting line and were trying to get as close as possible to the windward starting marker. In one collision Spain's *Juan Sebastian de Elcano* incurred a broken foremast and had to return to Bermuda; Argentina's *Libertad* had two torn sails, a smashed rail and a damaged lifeboat. In the second collision, Italy's *Gazella Primeiro* had to turn back with a broken topmast, while the *Mircea* (photo above) escaped unharmed. As it turned out, the sea remained so calm, that most of the ships had to use motor power to reach Newport. The ships remained tied up in Newport and received thousands of visitors, while almost two thousand cadets from the ships visited Mystic Seaport in Mystic, Connecticut.

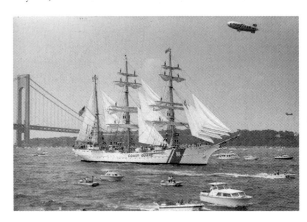

On Sunday, July 4, 1976, *Eagle* led the parade of tall ships from Sandy Hook to New York Harbor in OpSail '76 to celebrate the 200th birthday of the United States of America.

The *Danmark* (Denmark), *Christian Radich* (Norway), *Libertad* (Argentina), *Esmeralda* (Chile), *Gloria* (Columbia), *Gorch Fock II* (West Germany), *Nippon Maru* (Japan), *Dar Pomorza* (Poland), *Sagres* (Portugal), *Juan Sebastian de Elcano* (Spain), *Mircea* (Romania), *Tovarisch* and *Kruzenstern* (USSR), *Gazela Primeiro,* and *Amerigo Vespucci* (Italy) all followed.

The year 1976 saw another major change on board *Eagle*; the Coast Guard decided to admit women into cadet corps, and soon they also appeared on *Eagle*. Here they had to perform the same duties as the male cadets, and the women received no special treatment. Of course, the Coast Guard issued strict new guidelines for the new mixed environment; the swear words became no-nos, harassment called for strong punishment, and equal treatment of men and women became the new norm.

The female cadets were expected to handle the heavy lines just like the men had done, and when it came to making fast a line, they had to learn to do that also. Many a man was probably wondering if the ladies would be able to do all these things, but to the surprise of many, the ladies learned quickly and were able to do as well as the men.

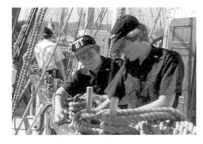

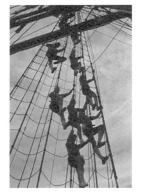

Soon the women cadets went up the ratlines together with the men, and soon one could not tell one from the other. They worked in the rigging, on the yards, and on deck the same as the men. Today this may not surprise the public anymore, but in 1976, the integration of women presented a major challenge, which the Coast Guard mastered with great success.

In 1978 *Eagle* made a West Coast summer training cruise, marking her visit there since 1965. On the trip *Eagle* visited Victoria and Vancouver, British Columbia to participate in the 200th anniversary of Captain Cook's exploration of the Pacific Northwest.

© USPS 1978

On August 4, 1978, the 188th birthday of the U.S. Coast Guard, the U.S Postal Service issued an *Eagle* postal card in Seattle, Washington. The 14-cent postal card bore a painting of *Eagle* done by Carl G. Evers, who had unveiled his painting on board *Eagle* in May. The ceremony was attended by Senior Assistant Postmaster General Carl C. Ulsaker, *Eagle* skipper Paul Welling, Academy Superintendent Rear Admiral Malcolm Clark, and other dignitaries. The original suggestion for the stamp had come from Commander John Swann, USCGR (Ret), a prominent philatelist and longtime Academy supporter.

On April 20, 1979, an unusual visitor came aboard: Herbert A. Werner, a New Jersey businessman, and the former captain of a deadly U-Boat during World War II. At the beginning of the war he had spent three months as a cadet on *Horst Wessel* before he entered the submarine service.

He served on several U-Boats and then was promoted to captain of his own U-Boat. He survived many engagements and had some hairy escapes when in 1943 the hunters became the hunted. After the Allied landings in Normandy, his U-Boat was the last out of France, and Captain Werner managed to bring his heavily damaged U-Boat back to Norway. He wrote down his experiences in the best seller *Iron Coffins*.

His impression of *Eagle*: "She still looks and feels like the same ship I knew so long ago."

By 1979, several surveys by the Coast Guard found that *Eagle*, after 43 years of continuous service, required a major overhaul. These findings were confirmed by the Germanischer Lloyd—the same company that had originally worked on the specifications when the ship was built. Since most of the original specifications had disappeared, the Coast Guard obtained some data from the *Gorch Fock II* which hade been built during the 1950s. Other specification came from U.S. Naval Ships classifications.

Intense analysis and planning resulted in a four-year plan (from 1979-83) of modernization in four phases: one emergency phase and three regular phases. From the deck down to the bilge, extensive refurbishing would provide nine new watertight bulkheads for safety, mast and rigging overhaul, new electrical systems, replacing the decks—a major effort, replacing of furnishings, watertight doors, teak deck installation, new ventilation and air conditioning, and a number of other improvements.

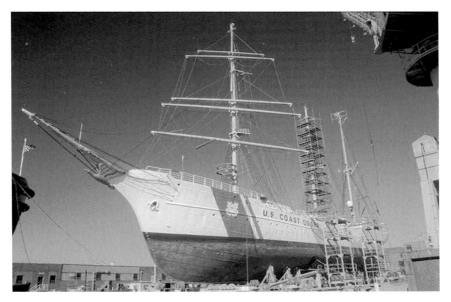

Most of the work was done at the U.S. Coast Guard Yard in Curtis Bay, Maryland, just outside of Baltimore. The photo above shows the main mast surrounded by scaffolding, up to 1979 most of the rigging had been original equipment from 1936.

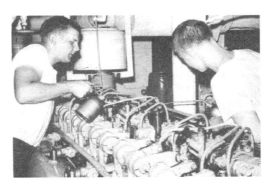

One major change also took out "Elmer," as it was affectionately called, the old 750 horsepower German M.A.N. Diesel auxiliary motor, which, built in 1932, had given almost 40 years of faithful service at speeds up to nine knots. The new motor, a turbo-charged 16-cylinder Caterpillar D-399 Diesel rated at 1,000 H.P. would give the ship a speed of over 12 knots and almost instantaneous response. It, too, quickly won the affection of the crew and now is known by the name of "Max." Old "Elmer," was eagerly accepted by the Portugese *Sagres*, where it supplied replacement parts for years. *Sagres* did not replace her "Elmer" until 1991.

With the new maintenance schedule—a program consistent with the rest of the Coast Guard fleet—*Eagle* could now look forward to a regular sailing schedule, a higher operating tempo, and year-round employment.

On August 28, 1980, a 23-year old seaman lost his life on board *Eagle* as the vessel was departing New London for Curtis Bay, Maryland. Richard A. Coe of West Sacramento, California was killed during a procedure called "stepping the mast." The mainmast top portion was lowered on a track in order to clear the Gold Star Bridge (U.S. Interstate 95) and was being raised to its normal position when a cable broke causing the upper mast to come crashing down 14 feet and crushing Seaman Coe.

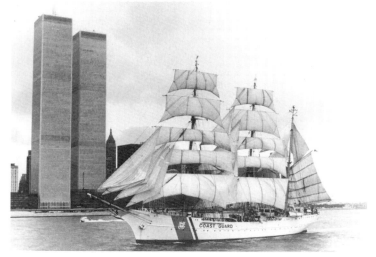

During the 1980s most of *Eagle*'s cruises concentrated on the Americas. During a visit to New York City she sailed by the World Trade Center in style under all sails; in 1980 she visited Boston for that city's 350th birthday, and in 1984 she visited Quebec on the occasion of that city's celebration of the 450th anniversary of the arrival of Jacques Cartier in North America.

In the early 1980s, the original teak decking aboard *Eagle* was replaced. During this time *Eagle* sailed with uncovered steel decks. During this time it was discovered that *Eagle*'s teak decks greatly improved the handling of the ship under sail.

Scheduled to take part in July 4th celebrations in New York City in 1982, *Eagle* rammed the pier at the Passenger Ship Terminal at 48th Street in New York City. *Eagle*'s figurehead was damaged and a foreyard was cracked in two. She docked at Governors Island for repairs.

In 1984, New Orleans hosted the Louisiana World Exposition and attracted visitors from all over the world. *Eagle* also paid a visit to the city on this occasion and was greeted with true southern hospitality. The ship was open to the public, and the crowds of visitors ran into the tens of thousands. By this time Captain Ernst Cummings had assumed command. This trip south had Officer Candidates School (OCS) students on board instead of cadets, a precedent that led to more OCS cruises in the future.

Sports Illustrated magazine writer Sarah Ballard and photographer Bill Eppridge took to sea aboard *Eagle* in 1984 to view the Bermuda-to-Halifax Tall Ships race. During the race *Eagle* sailed into a squall blowing winds of up to 70 knots. *Eagle*'s starboard rail was in the water and her masts hung out over the seas at a 50-degree angle. The same storm capsized and sank another racer, the 117-foot *Marques.* Nineteen were lost, 9 survived.

Eagle, 75 miles north of *Marques* hove to and was on standby for a search-and-rescue (SAR) operation. She was later released from standby SAR status and proceeded to Nova Scotia.

Ms. Ballard chronicled the voyage in an 11-page article titled, "A Race Back in Time" which appeared in the October 1, 1984 issue.

In celebration of *Eagle*'s 50th Anniversary as a U.S. Coast Guard training ship, author George Putz compiled *Eagle: America's Sailing Square-Rigger.* The 152-page book was published by Pequot Press in 1986. In a foreword to the work, veteran newsman and *Eagle* admirer Walter Cronkite called *Eagle*, "A unique, magnificent, majestic manifestation of the American spirit."

On July 4th 1986 New York served as the host to a "Parade of Sail" on the occasion of "Salute to Liberty," celebrating the centennial of the Statue of Liberty.

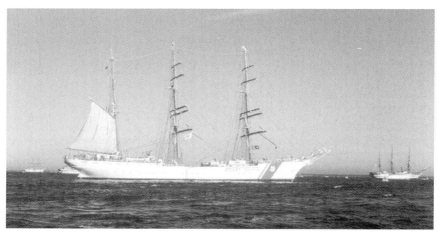

Because of my status as "the oldest living cadet" (the words of Captain Cummings), the Coast Guard had also invited my wife and me as guests. At three in the morning we got up and drove to Sandy Hook, from where a boat took us guests to the *Eagle* which lay at anchor in the bay with all the Tall Ships around gently swaying in the morning breeze under a hot sun.

On board we had coffee and donuts and then milled around the deck while *Eagle* got under way, with all the other ships forming in line behind us. At first we enjoyed a good breeze and the crew was looking forward to sailing into New York, but the wind died down and soon we were broiling under the sun.

The flags shown here are November, Romeo, Charlie, Bravo, (NRCB) *Eagle*'s International Call Sign—or as the cadets remember: "Never Refuse Cold Beer."

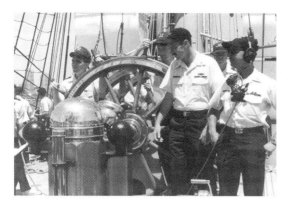

Once past the Verrazano Bridge the boat traffic became hair-raising—how the men and women of *Eagle* managed to steer through the hundreds of boats brought nothing but admiration from us. Some of the boats were sight-seeing boats filled with passengers who all tried to get as close as possible to get good photos of the ships until some Coast Guard cutters began to chase them away. Back behind a line on the Jersey side set up by the Coast Guard waited thousands of small boats patiently, and the shores were packed with people. Meanwhile Walter Cronkite fueled the excitement with his live reporting from the bridge.

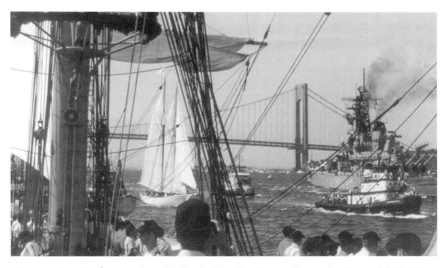

Once again, *Eagle* served as the lead ship. She led an imposing line of Tall Ships from Sandy Hook under the Verrazano Bridge past the Statue of Liberty up the Hudson to the George Washington Bridge, from where the ships traveled to their individual berths. The governors of New Jersey and Connecticut counted among the guests. The Tall Ships included *Esmeralda, Gloria, Danmark, Guayas, Belem, Palinuro, Amerigo Vespucci, Soerlandet, Christian Radich, Sagres, Juan Sebastian de Elcano, Gazela, Sea Cloud, Eagle, Kruzenstern, Tovarisch*—a most impressive assembly, viewed by several million spectators ashore and many millions all around the world.

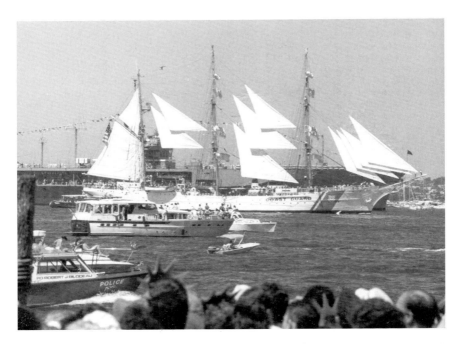

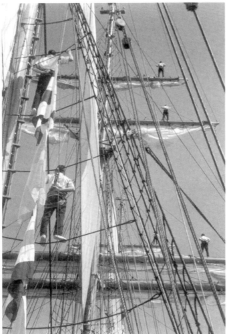

On *Eagle* the sails remained furled except for the staysails and mizzen sails. The ships motored almost the whole way. Once we passed the Statue of Liberty, tugboats greeted us with loud toots and huge plumes of foam and the spectators on the shores waved at us. Some cadets stood on the yards in parade formation as we passed in review past the reviewing stand on Governors Island, from where President and Mrs. Nancy Reagan waved at us— she unmistakable in her red dress.

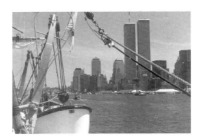

IX. The Journey to Australia

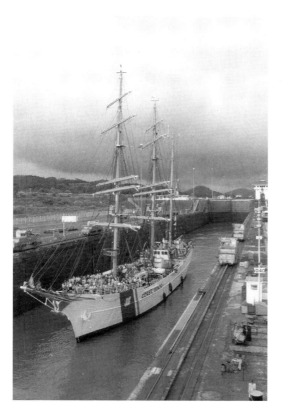

At the invitation of Australia's Prime Minister Robert Hawke, and by direction of President Ronald Reagan, the U.S. Coast Guard designated the Barque *Eagle* to proceed to Australia to represent the United States at the festivities celebrating Australia's Bicentennial. Under the command of Captain Ernst M. Cummings, *Eagle* left New London on September 10, 1987, after departure ceremonies with author and Coast Guard veteran Alex Haley as Master of Ceremonies and speeches by Australia's Ambassador Rawdon Dalrymple, and Mrs. Elizabeth Dole, Secretary of Transportation.

Captain Ernst Cummings commanded *Eagle* on her six month voyage to Australia.

A New Figurehead

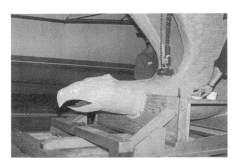

Figureheads on ships show pride of ownership, and before the trip to Australia, the Coast Guard decided to have the feathers and skin of the *Eagle*'s figurehead eagle regilded. Figureheads have an important place in maritime history, from the gilded heads of the Egyptian ships to the serpentine prows of the Viking longships, from the animal heads of the Hanseatic cogs to the eagle of the U.S. Coast Guard's *Eagle*.

Careful hands took the 12-feet long figurehead, carved of Honduras mahogany and weighing almost a ton, off the bow, mounted it on a pallet, and took it to a shop in Maryland, which had won the competitive bidding. Since the bird is hand-carved, machine sanding is out, and all sanding is done by hand. Then craftsmen carefully fill all cracks and sand them. Finally they polish the whole bird to a uniform, even finish. Now the workers apply several coats of high-quality yacht enamel, making the bird ready for gilding.

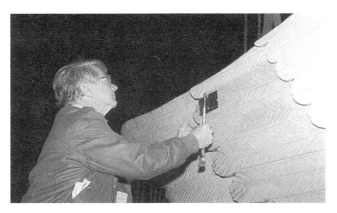

Gilding with gold? Yes, not the cheap alloy, but only real gold will withstand the rigors of the saltwater. Only gold of the highest quality will do, and it comes in very thin layers. Would you believe—23 carat gold and no thicker than 1/200,000th of an inch? Broken into little 3 3/8 inch squares, the gold becomes very malleable and flexible, so that craftsmen can hammer and draw the squares onto the feathers of the eagle.

To make sure the gold sticks firmly, the gilder applies a special adhesive for the area he plans to cover with gold. Since the adhesive goes tacky in less than two hours, he can apply only a little bit at a time. And so the gilders slowly apply the gold squares, careful to reach all the corners and crannies without damaging the parts already done. Finally about 5,000 gold squares have been applied.

Now the painters come and apply paint to the eagle's tongue, eyes, and beak. Then comes the most difficult part: painting the Coast Guard seal on, but the painter has to do this in an upside-down position, making it a painful and laborious exercise of the muscles.

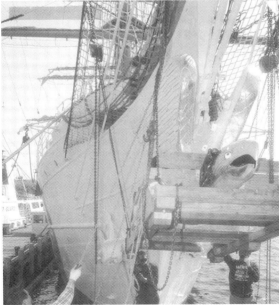

When all has been done, the eagle is ready for the trip back to New London. The pallet is rolled out of the shed, covered with a container, and put on a trailer. Meanwhile the shop has attached new brackets to the ship, and when the bird arrives, it can be lifted up and bolted in place. Once the eagle is in place, the gilders come once more to cover whatever minor damage the bird has incurred. Finally *Eagle* has a figurehead again is ready for the big trip.

Eagle's Australia Schedule:

Phase I

New London, Connecticut
West Palm Beach Florida
Rodman, Panama
Cuyaquil, Equador
Santa Cruz, Galapagos Islands
Papeete, Tahiti
Bora Bora, Tahiti
Pago Pago, American Samoa
Apia, Western Samoa
Nukalofa, Tonga
Vava'u, Tonga
Lord Howe Island, Australia
New Castle, Australia
Brisbane, Australia

Phase II

Brisbane, Australia
Hobart, Tasmania
Sydney, Australia
Manly, Australia
Pago Pago, American Samoa
Honolulu, Hawaii
Port Angeles, Washington
Seattle, Washington
San Francisco, California
Los Angeles, California
Acapulco, Mexico
Rodman, Panama
Miami, Florida
New London, Connecticut

The following map shows the trip as a map with proposed dates. Please note that the following two destinations were later stricken:

Vanuatu December 8
Cartegena September 27

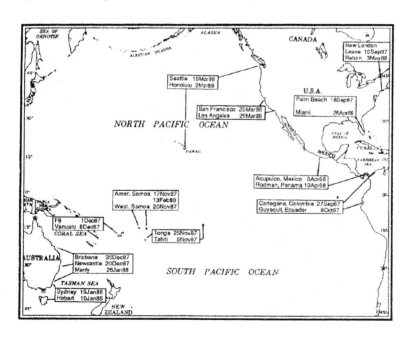

By beginning of October *Eagle* had passed the Panama Canal and gained the Pacific Ocean. Soon, as the ship passed the equator, *Neptunus Rex*, Ruler of the Raging Main (Lieutenant B.M. Ross), boarded the ship and baptized the newcomers, or—in his language—"ushered a new gaggle of slimy pollywogs into the brethren of the trusty shellback." While welcoming his eight returning apostles, Neptune gave just retribution to the 200 slimy pollywogs, who had come unbidden into his domain. After a memorable visit to the Galapagos Islands with its huge tortoises and spitting iguanas the crew celebrated Halloween at sea with appropriate costumes of witches, scarecrows, pumpkins, etc.

In early November came the enchanting beauty and warm hospitality of Bora Bora with its volcanic peaks, white beaches, palm trees, and emerald sea. In Mid-November Pago Pago, Samoa greeted the visitors with a warm welcome, fresh pineapples, and tours of its lush country. After visits to Western Samoa (where Captain Cummings played golf with the King) and Tonga, *Eagle* hoisted "Old Glory" as she passed the International Date Line. Here the Executive Officer, LCDR Robert Petko rests on the rail and behind him Tafua—the actual site of the mutiny on the *Bounty*.

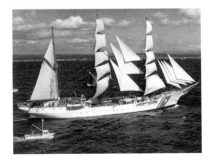

In December, while passing more beautiful islands, all on board competed in the Square Rigger Olympics which included knot-tying, setting headsail, tossing lines, and the popular "egg-drop" event (where eggs are dropped from the lowest yard and must be caught). By mid-December *Eagle* had reached Australia as she dropped anchor at Lord Howe Island, considered Australia's most beautiful island. Here the cadets scrubbed and painted to get the "Lady" ready for the coming weeks.

After a welcome ceremony with distinguished guests, the city of Newcastle gave the men and women of *Eagle* a barbecue dinner, Christmas Carols by candlelight, local tours, softball matches, and Christmas visits with local families. The port call to Brisbane drew more than 100,000 visitors to *Eagle* and other ships, overwhelming the local authorities and facilities. Here cadets and crew had a chance to see some of the local animals like the kangaroo and the Koala bears.

The trip to Hobart brought daily sail exercises in preparation for the coming sail race from Hobart to Sydney. Captain Cummings reported: "… all hands are engaged in final preparations and plans for the race, the likely positions for tacking, and the best sail trim for the conditions expected… Today we again improved our performance in setting sail, dousing sail, and tacking. Third class cadets are becoming agile creatures on the rigging, while first class cadets are growing in confidence as watch officers and watch captains."

After a visit by Robert Hawke, Australia's Prime Minister, *Eagle* departed Hobart for the starting line, where 160 entrants awaited the start signal. For a race all vessels are grouped into four classes A through D. Together with other large ships *Eagle* falls into Class A, and in this race thirteen other vessels participated in her class. The race would take the ships through the "Roaring Forties," an area between the latitudes 40° and 55° where prevailing westerly winds blow between 10 and 30 knots.

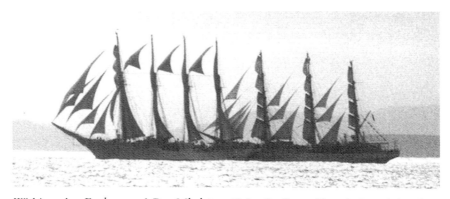

Within a day *Eagle* passed *Dar Mlodziezy* (Poland), *Guyas* (Ecuador), and the giant *Juan Sebastian De Elcano* (Spain), among others, and was racing along, but then the winds turned northerly, and the ships had to beat their way upwind very slowly. Ultimately *Eagle* had to withdraw from the race in order to honor her commitment in Sydney, to the great disappointment of crew and cadets.

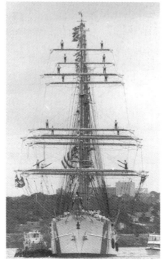

The ten days in Sydney represented the highlight of the tour. It included many prominent visitors, ceremonies, and a Parade of Sail in front of the famous Sydney Opera House, passing Australia's Prime Minister as well as Prince Charles and Lady Diana.

Singer/actress Olivia Newton John also came aboard in Sydney, where she was making a special for the HBO network; A young native boy proudly shows his *Eagle* medal.

At the end of January, *Eagle* got underway for the return trip with Pago Pago, American Samoa, as the next stop. The *Eagle* report read:

"The *Eagle* came upon the Manua Islands, sixty miles west of Pago Pago... a swim was authorized, and the uproar at quarters displayed the pleasure and enthusiasm of cadets and crew. The small and sculptured cove offered tropical beauty as crew members waded and snorkeled in the warm waters. After a refreshing day of swimming and golden sunshine, a spectacular rainbow formed over the island, just as a brief shower ended."

The report describes a similar scenario in Pago Pago. Here a Coast Guard C-130 transport plane brought in needed supplies. Upon crossing the equator, once again Neptune came aboard and transformed the Pollywogs to Golden Shellbacks.

On February 22, *Eagle* continued toward Honolulu and cadets and crew made *Eagle* ready for port.

On the trip a sudden gust of 70 knots parted halyards and blew out the mizzen topmast staysail, the main topmast and the inner jib.

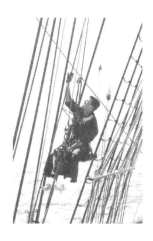

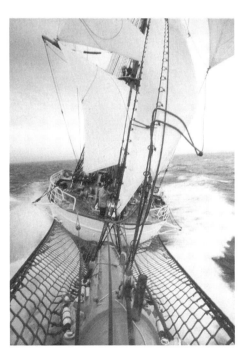

As *Eagle* pulled into Honolulu, cadets "layed up and out " on the yard arms to "harbor furl" the sails. "Harbor furling" the sails means pulling the sails onto the yard arms and tucking them very tightly so that the sail lies flat on top of the yard. *Eagle* had sailed 21,600 nautical miles, the equivalent of circumnavigating the earth at the equator. Honolulu brought shore leave, a well-deserved rest for all, and a sleep in a real bed for some.

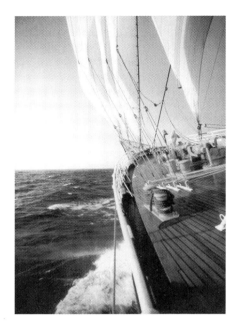

On March 19, *Eagle* docked in Seattle for a first visit back to the continental U.S. Then came a visit to San Francisco, which not only provided for a most interesting visit, but also brought back the warmer weather, short-sleeve shirts, and Bermuda shorts. *Eagle* sailed under the Golden Gate Bridge with full sails, a magnificent spectacle on Coast Guard Appreciation Day. Next the "Lady" visited Southern California and then Acapulco, before passing through the Panama Canal again on the way to Miami and home.

The ship arrived in New London on May 6, 1988. A warm letter of appreciation from President Ronald Reagan waited for the crew, as did a local welcoming committee.

Trip Statistics:

Length of Trip	8 months,
Days Underway	180 days
Nautical Miles Traveled:	30,730
Fuel Expended	183,00 gallons
Potable Water Expended	735,276 gallons
Lube Oil Expended	1,337 gallons
Main Engine Use	3,026 hours
Service Generator Use	5,466 hours
Cadets Trained	275

X. Toward a New Professionalism
1989-96

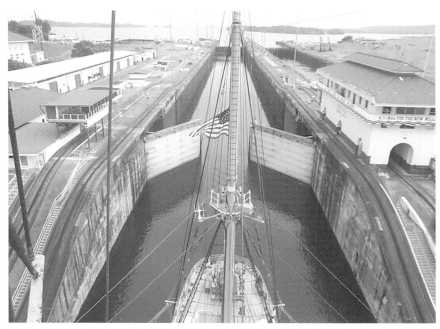

After the 1988 cruise to Australia, the Coast Guard continued the modern pattern of extended operations, which had begun in 1976. The new emphasis on maintenance began to pay off. While most of the standing rigging had been original equipment, the wire rope standing rigging was renewed mast by mast in successive years. The expenses for yard maintenance began to exceed a million dollars a year, and each dry dock stay added more than half a million dollars.

Meanwhile, the permanent personnel also increased from 5 officers and 31 enlisted men in 1990 (augmented in the summer by up to 15 enlisted personnel), to 6 officers and 50 enlisted men in 2006, as increased maintenance, a greater emphasis on safety, and a longer training schedule demanded more manpower.

As for training cadets, new arrivals, i.e. 4th class cadets (Swabs), got "shorts," i.e. one week on board *Eagle*; the 3rd class cadets spent six weeks on board. Some 2nd and 1st class cadets sailed as cadre with the lower classes: an upper-class group of 15-20 continued to provide leadership to about 150 lower-class cadets.

For the Officer Candidates (OCS)—personnel selected to become officers—the overall training schedule was expanded to 17 weeks. They would spend two weeks on board *Eagle*, before and after the cadet courses, i.e. mostly in spring and fall. They would train on board without any upper-class leadership, but they have, obviously, extensive experience. Whereas the average age of cadets is 19, the OCS groups show an average age of 27 years.

The new regimen gradually began to show results. During the year October 2004 through September 2005 *Eagle* had 217 operational days; the "Lady" has truly become a highly efficient sail-training ship.

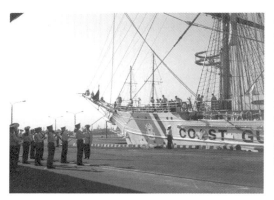

Shortly before the Berlin Wall crumbled, *Eagle* visited Leningrad in the summer of 1989, her first visit ever. Sailing past Scandinavia, the crew enjoyed the short nights and mild temperatures of the northern mid-summer. Glasnost was already softening the atmosphere in the USSR, and *Eagle* and her crew received a warm welcome.

As guests of the Frunze, the Soviet naval academy, cadets and crew visited the city's many sights, learned a bit about Leningrad's (later renamed St. Petersburg) role in Russian history, and exchanged many items and trinkets. At the same time the Coast Guard band also visited, and American marches and Jazz delighted the Russians. The Yale Glee Club and the New London Eugene O'Neil Center also gave performances. A delegation from the ship laid a wreath at the cemetery, where 650,000 dead lay buried, victims of the German siege of 1941-44.

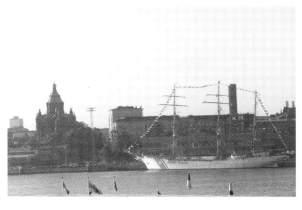

Eagle's three day visit to Leningrad (later the name of the city was changed back to St. Petersburg) was, for most on board, an unforgettable experience. *Eagle* was the first American warship to visit the USSR since 1975.

During the 1990 Boston Harborfest *Eagle* was high-jacked. Our "Lady" had arrived in Boston for the 4th of July celebrations, but suddenly she was ordered to leave, go to Portsmouth, New Hampshire, pick up White House chief of Staff John Sununu, Vice President Dan Quayle, Transportation Secretary Sam Skinner, Admiral J. William Kime, Commandant of the Coast

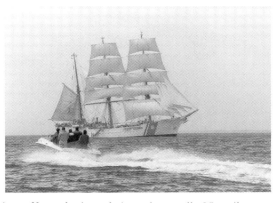

Guard, and the presidential staff, and then bring them all 85 miles to Kennebunkport, Maine.

In Kennebunkport, President George Bush came aboard and everybody then viewed a fire-works display to celebrate the 200th birthday of the U.S. Coast Guard. After the last incendiary burst, Coast Guard 41-footers ferried Mr. Bush and his guests back to Kennebunkport, and *Eagle* returned to Boston Harbor and joined the late morning parade and escorted the USS *Constitution* on her annual turn-around cruise.

One of the guests especially delighted the other guests, the cadets, and the crew: Marilyn Quayle, the attractive and vivacious wife of Vice President Dan Quayle. She not only took great interest in the ship and its crew, she also quite happily climbed up into the rigging, with anxious crew members and secret service agents close behind her. Here she posed with Boatswain Mate 1st Class Karl Dillmann; a secret service agent to her left. Karl Dillmann, by the way, spent altogether 11 years on *Eagle*; he left her in 2003, when the crew called him affectionately "Chief."

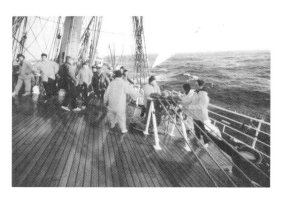

In April 1991 *Eagle* left for the Azores from the Coast Guard Training Center in Yorktown, Virginia. The next day a stiff breeze sprung up and soon, with all sails set, she was rolling along at more than 16 knots. She sailed more than 12 straight days and 1,900 miles, almost 1,200 miles the first five days alone. On the way *Eagle* received orders to give medical assistance to a sick crewmember of a Greek tanker nearby. In strong winds *Eagle* directed the tanker on a parallel course, and with outstanding seamanship all around the small boat took the medical officer to the tanker. After proper diagnosis and treatment the medical officer returned, and *Eagle* resumed her cruise. Everybody on board was excited about this opportunity to help someone in distress.

In 1492 Christopher Columbus was the first European to record seeing the new continent which would be called North America. Come 1992, America naturally celebrated the 500th anniversary of this "discovery" and paid tribute to Columbus. The international community of Tall Ships celebrated this occasion with a great get-together in San Juan, Puerto Rico, and, as might be expected, *Eagle* came as a representative of the United States of America.

During the stay in San Juan the crews of the Tall Ships had ample opportunity to visit other ships, and since three of *Eagle*'s sister ships were in port, it was quite natural that the captains of the Portuguese *Sagres*, of the Russian *Tovarisch* (the former *Gorch Fock*), and of the German *Gorch Fock II* should meet on board *Eagle* with Captain David Wood. The four captains agreed to go out sailing together to provide a unique viewing and photo opportunity to the large sailing assembly and to the public.

When the time came for the ships to go out, however, the *Tovarisch* did not join but went her own way. Some people thought that the Russian captain had misunderstood the agreement, but others say that the Russian navy was in dire financial straights and that *Tovarisch* showed signs of neglect, and the captain did not want his ship to be photographed with the others. In any case, the photo, taken from a plane, shows *Eagle*, *Gorch Fock II* and *Sagres* sailing together.

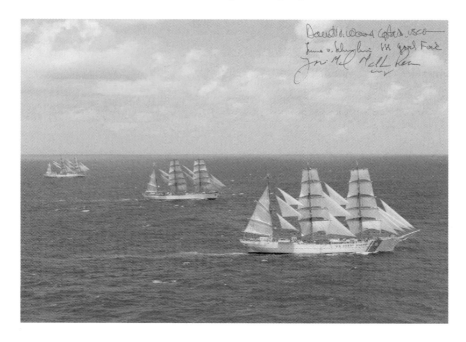

On this occasion BM1 Karl Dillmann met Kapitän Immo von Schnurrbein of the *Gorch Fock II*. As he was impressed with Karl's fluent German, von Schnurrbein invited Karl to spend some time sailing on the *Gorch Fock II*. Karl sailed on board for a short trip that summer and agains later for a longer trip from Portugal to Germany.

Karl saw a happy crew on the *Gorch Fock II*—von Schnurrbein was a very good sailor and the crew affectionately referred to him as "Immo." Karl was impressed with the speed and precision that the crew exhibited during sail maneuvers. On the German ship every cadet has a fixed station (as I remember it from 1944), and the cadet will always man that station. That makes for speedy and precise exercises. Supervisory and control functions are exercised by officers and petty officers, not cadets.

By comparison, on *Eagle* the cadets have no such fixed stations; every cadet is expected to handle any station at any time—on deck as well as in the rigging. This method probably results in less speedy and precise exercises, but on the other hand Coast Guard cadets learn more duties on more stations then their German colleagues. In addition Coast Guard cadets are expected to learn and perform functions such as OOD (Officer Of the Deck), Mast Captain, and many others. As a result Coast Guard cadets learn more flexibility, independence, and leadership.

Later that summer of 1992, *Eagle*, together with 30 other ships, continued to Boston to for the 500th anniversary of Christopher Columbus' first journey to the New World. 1,500,000 spectators flocked to the waterfront, cannons boomed, and fire boats shot their fountains in the air. Again *Eagle* with the frigate USS *Constitution* led the huge parade of 40 ships. For Captain David V. V. Wood this Parade of Sail was to be his last regatta; he planned to retire after 30 years in the Coast Guard, the last four years as captain of *Eagle*. His successor was Captain Patrick Stillman.

In 1995, *Eagle* led a parade of tall ships into the harbor of New Haven, Connecticut, as the highlight of "Sights and Sound," a cultural festival during the Special Olympics.

In 1996 *Eagle* served as a backdrop behind the presidential podium when President William Clinton delivered the graduation speech at the U.S. Coast Guard Academy.

Visit to Hamburg 1996 (The "Lady's" 60th birthday)

After taking command of *Eagle* in 1995, Captain Donald Grosse found out that 1996 would be the 60th anniversary of the ship's launching as well as her 50th anniversary in the U.S. Coast Guard, he decided that we should try to sway the Academy to send *Eagle* to Hamburg that summer. So I started a campaign of getting as many people as possible to write letters requesting a visit to Hamburg, and quite a few such letters did arrive, mostly from Germany. We knew that plans were in place to send *Eagle* to the summer Olympic games in Georgia, but we hoped that our write-in campaign would succeed. Great was our joy when the Coast Guard announced that the "Lady" would go to Hamburg on her way to St. Petersburg. Her new commanding officer was to be Captain Robert Papp.

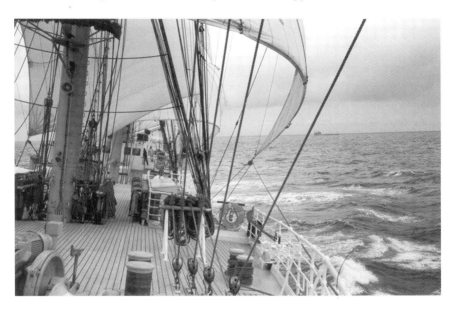

After a very calm trip ("no breeze, the sea was like glass") from Ireland through the English Channel, *Eagle* stopped in Amsterdam behind the *Pride of Baltimore II*. The next day the wind picked up to a welcome breeze of 25 knots, and under full sails *Eagle* pointed her bow towards Hamburg. Captain Papp, crew, cadets, and visitors all enjoyed the wind and the waves of the North Sea, as the German coast appeared to starboard.

On board I met Howard Slotnick. Howard learned to sail in Sheepshead Bay, Brooklyn, New York. In 1970, he became a trustee of the South Street Seaport Museum, and during the early 70s he and four other members organized, and ran the Bicentennial celebration OpSail 1976, a tremendous success. He also helped organize the other OpSail events of the following years. Howard has been a true friend of the U.S. Coast Guard for many years and has given a great deal of his time to serve on many commissions. Howard has sailed on *Eagle* numerous times, has become a friend to many captains, and can tell you many a good yarn about famous people and the Coast Guard.

As *Eagle* was about to enter the Elbe River, a German naval tender brought the river pilot and this liaison officer, whose sole duty was the welfare of *Eagle* and her crew while in Germany. It became obvious early that the German Navy and the City of Hamburg were eagerly awaiting the guests and were prepared to make this return a memorable one. Soon *Eagle* began the 50-miles trip up river to visit Hamburg, where Blohm & Voss had launched the ship 60 years ago almost to the day.

As *Eagle* motored up the river, ships from all over the world passed by with greetings and waves. Container ships alternated with freighters, passenger ships, and little sailboats on this very busy waterway. Near Hamburg the ship passed the "Welcome Court," an age-old tradition, that greets every arriving vessel.

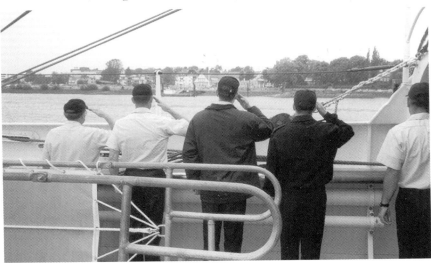

One evening in Hamburg, I had dinner with Captain Robert Papp and Howard Slotnick. Captain Papp turned to me and said: "Well, Tido, you probably think that your write-in campaign brought *Eagle* to Hamburg?" I said, "Absolutely!" He went on: "I hate to disappoint you, but it was President Gorbachev of Russia, who prevailed on our President to send *Eagle* to the 300th birthday celebration of St. Petersburg." I paused for a moment, surprised; but then shot back: "Maybe, but I caused the stop in Hamburg, and that is all I wanted." Captain Papp smiled benevolently.

Then Howard chipped in: "Tido, how do you think the *Eagle* visit to Kiel in 1972 came about?" I shook my head. "The German Chancellor, Willy Brandt, once had dinner with President Nixon. At the end of the toasts, Willy Brandt, raised his glass and toasted to Nixon: 'Mister president, we have only two favors to ask of you: one—do not reduce the number of U.S. troops in Germany, and two—send *Eagle* to Kiel for the Olympic games in 1972!' Whereupon Nixon rose and graciously said: "Both wishes granted, Mr. Chancellor." Afterwards Nixon turned to his aide: 'Who the hell is *Eagle*?'"

I must have looked surprised, because Howard continued: " How do you think the trip to Australia came about? The Australian Premier asked his Ambassador to ask for an audience with President Ronald Reagan and asked for the U.S. to send *Eagle* to represent the United States at the great Australian 200-year celebration. Whenever someone wants *Eagle*, they ask the President. In diplomatic circles, that is well known. How do you think we—the people who organized OpSail 86—got *Eagle* and President Reagan to come? We had to use our own ambassadors."

In Hamburg, *Eagle* found a reserved pier in St. Pauli not far from the world famous Reeperbahn and across the water from the Blohm & Voss shipyard. While a huge Stars and Stripes fluttered from the mizzenmast, and the long line of signal flags and pennants created a rainbow of colors from the bowsprit across the tops of all masts down to the stern, long lines of visitors waited patiently to come aboard.

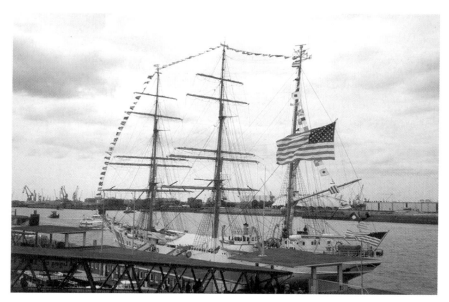

Blohm & Voss invited *Eagle*'s officers and crew to a very formal luncheon in the historic restaurant in the Hamburg Town Hall. Here the president of the shipyard was hosting the large gathering which was celebrating not only the visitors but also the 60th anniversary of the ship's launch.

For cadets and crew these were heady days with many invitations such as a formal lunch at city hall given by Blohm & Voss, tours to the city's naval museums, and guided tours of the city, completely rebuilt from the deadly firestorm of 1943.

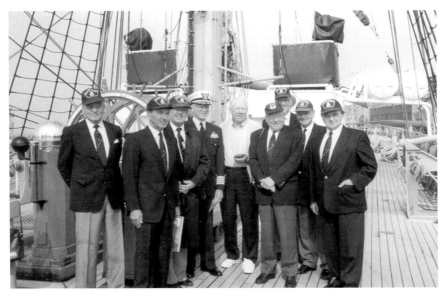

Among the visitors to the ship were some of the author's buddies who had all served on the *Horst Wessel* in 1944. They critically inspected their old ship and marveled at her condition, but were surprised about coke machines, the loss of the capstan, and the presence of women on board. Here they pose with the author and Captain Papp, with whom they had a lively conversation.

On the last day German naval veterans brought their wives on board for a reunion of sorts. Their choir brought enjoyment to all with their joyous renditions of German sea chanties. Crew and cadets mixed with the visitors, and many tales of yesteryear experienced a revival.

In the early morning hours of a foggy Sunday morning *Eagle* moved back into the river on her way around Denmark into the Baltic, first to Warnemünde, and then on to St. Petersburg, Russia.

When *Eagle* returned to New London in September Admiral Paul Versaw, Superintendant of the U.S. Coast Guard Academy, welcomed ship and crew back from the trip. He reminded the audience that *Eagle* had first arrived here in 1946 and was now celebrating her 50th birthday in the Coast Guard.

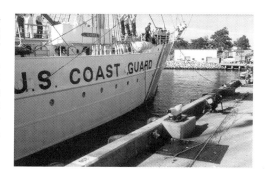

Before he cut the cake, the Admiral gave special recognition to the crew and some of the invited guests, who welcomed *Eagle* and attended the birthday celebration.

In June 1998, while *Eagle* was cruising the Caribbean, Seaman Apprentice Gregory La Fond fell from the rigging onto the deck. A helicopter brought him to a hospital in Puerto Rico, where he was pronounced dead. SA La Fond was buried in his hometown of Exeter, New Hampshire.

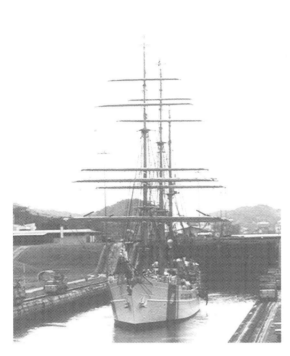

In 1999 *Eagle* went on an extended tour to the West Coast and passed through the Panama Canal twice. For *Eagle*'s crew a passage through the canal and its many interesting locks represented an exciting experience. Depending on traffic a trip through the canal takes about 10 hours, often more if many ships are waiting.

XI. The New Milennium

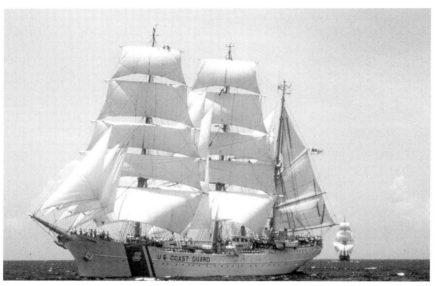

The year 2000 saw Operation Sail 2000 in the United States. Starting with Jacksonville, Florida, OPSAIL moved up the coast, going to New York on July 4th. This time the port of New London, Connecticut, homeport to *Eagle* and the home of the Coast Guard Academy, had its own OPSAIL weekend after New York.

The author and his wife Barbara were special guests aboard *Eagle* for the the New London OpSail celebration.

Fellow Tall Ships made the trip to New London, including *Eagle*'s sister ship *Sagres* (Portugal).

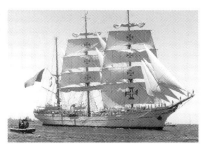

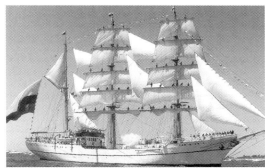

Gloria (Columbia), a bark, was built of steel in 1968 in Bilbao, Spain. She looks similar to *Eagle*, but is shorter—she has a length of only 255 feet. Her raised bridge with the enclosed pilothouse makes her identification easy.

Libertad (Argentina), a full-rigged ship, was built of steel 1959 in Argentina. With a length of 356 feet, she is a fast traveler and has garnered many medals. During the 1960s she made the crossing from Canada to Ireland in 8½ days.

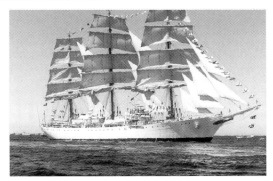

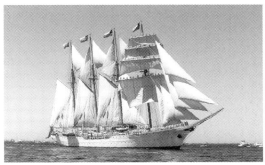

Esmeralda (Chile), a four-masted barkentine with a length of 353 feet, was built 1952 in Cadiz, Spain, as a sister ship of the mighty *Juan Sebastian del Elcano*. She has as a figurehead the condor, Chile's national bird. She can carry 330 officers, crew, and cadets.

Navigation instruction has always been a priority on board *Eagle*.

During *Eagle*'s return trip across the Atlantic from Gibraltar in 2001, Captain Ivan Luke had everone on board to agree to use only celestial navigation until landfall.

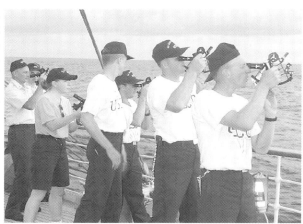

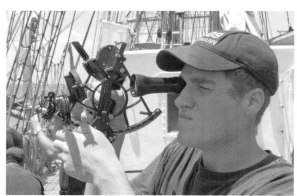

Captain Luke told cadets and crew to navigate very carefully if they wanted to stop in Bermuda. The small island would be easy to miss. Otherwise *Eagle* would return to New London.

Everybody took great pains to get exact readings from their sextants. Laptop computers were made available for reductions. Fixes were taken and plotted every fifteen minutes.

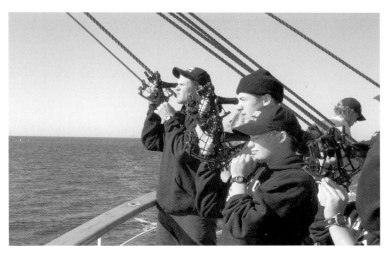

In the end, celestial navigation proved as accurate as any electronic system. *Eagle's* position was only two miles off.

Eagle's story of her passage from Nazi Germany to the U.S. Coast Guard was told in the 2001 book *The Barque of Saviors* (Houghton Mifflin) by Russell Drumm.

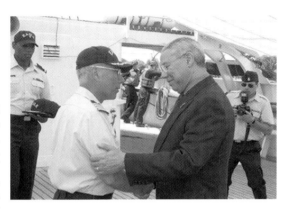

In 2002 *Eagle* visited Washington, D.C., and the Secretary of Transportation invited other cabinet members including Secretary of Defense Donald Rumsfeld, and Secretary of State Colin Powell on board to have lunch with Captain Ivan Luke.

Singer Jimmy Buffett and his son set sail aboard *Eagle* in August 2002. He gave a free concert on the ship's waist.

In June 2004, *Eagle* accidentally lost an anchor while in Jacksonville, Florida. The 3,800-pound anchor, the remaining original from 1936, broke free from its chain during a routine maneuver when leaving the dock during the "Sail Jacksonville" festival. The anchor was later recovered by a Coast Guard buoy tender. The other original anchor was lost in the Chesapeake Bay in 1967 and has not been recovered.

146

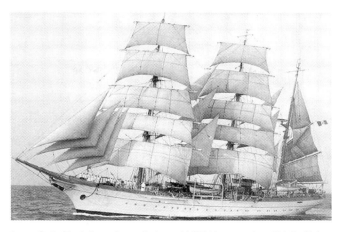

In 2004, the American Sail Training Association (ASTA) ran the "Tall Ships Challenge" with races from Jacksonville, Florida, to various cities along the east coast and ending in St. John, New Brunswick, Canada.

Their stop in New London, Connecticut, gave visitors an opportunity to go on board another of *Eagle*'s sister ships, the Romanian bark *Mircea*, built in 1938 in Hamburg. On this trip she had left Constanta, Romania on April 19, had traveled via Italy, Las Palmas, Hamilton, Bermuda, Charleston, Baltimore, and Newport to New London, and was due to return to Constanta on September 24. Unlike the *Eagle*, the *Mircea* had left arrangements on board pretty much as they had been in 1938, so this was an interesting look at what *Eagle* looked like some time ago.

Below decks one could still find the original tables and benches, shown here clamped to the overhead when not in use. It always takes several cadets to take the tables down and to lift them up again.

The hammocks, still in use abaord *Mircea*, can be attached to one of the many overhead jack stays with a slipknot, and serve best when the ship is in motion.

In 2005, *Eagle* visited Bremerhaven, Germany. It was the first time that *Eagle* visited the city from where she had left in 1946, and the port city rolled out the red carpet for their American guests.

The son of the last German captain, Peter Schnibbe, a well-known painter, appeared on board *Eagle* and presented —in the presence of the German press—a painting of the ship in Bremerhaven after the war showing the "Lady," bare-masted and deserted, before the ruins of the city and under a glaringly red sky. Captain Eric Shaw accepted the painting and showed Mr. Schnibbe through the ship. Mr. Schnibbe's father had commanded *Horst Wessel* through her last German years, had handed her over to the U.S. Coast Guard after the war, and had accompanied the new captain on the trip to the United States.

During her stay, in Bremerhaven many of her old German cadets also visited the "Lady," made courtesy calls on the captain, took guided tours through the ship, and commended their hosts on the excellent condition of the ship. Here a visitor sits on the bench next to the "Captain's Coffin" (as the Germans used to call it, and cadets still do), where he used to sit as a German cadet in 1944. While it resembles a coffin, it houses the ship's emergency steering gear.

After Bremerhaven *Eagle* sailed across the North Sea to Plymouth, England, where she participated—together with hundreds of other vessels from all over the world—in the festivities celebrating Admiral Horatio Nelson's victory at Trafalgar in 1805. Again *Eagle* proved a worthy representative of the United States.

There are many voyages and adventures ahead for *Eagle*.

She will continue to train the Coast Guard's future officers for many years to come.

Those that know the ship well believe that with regular maintenance and periodic equipment updates, the well-built rig can sail on virtually indefinitely.

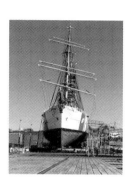

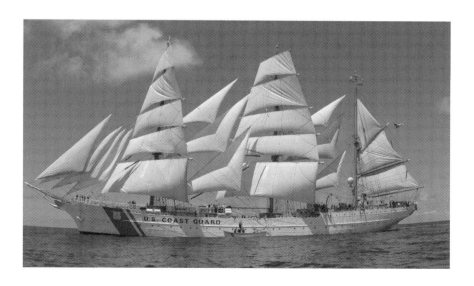

APPENDIX

A - List of Commanding Officers

Kommandanten *Segelschulschiff Horst Wessel*:

Kapitän August Thiele, 1936-38

Korvettenkapitän Kurt Weyher, 1939

Kapitänleutnant Martin Kretschmar, 1940

Fregattenkapitän Peter Ernst Eiffe, 1941-42

Kapitänleutnant Barthold Schnibbe, 1942-46

Commanding Officers *U.S.C.G. Barque Eagle*:

Captain Gordon P. McGowan, 1946-47

Captain Miles Imlay, 1947-48

Captain Carl B. Olsen, 1949

Captain Carl B. Bowman, 1950-54

Captain Karl O. A. Zittel, 1954-58

Captain William B. Ellis, 1959

Captain Chester I. Steele, 1960-61

Captain Robert A. Schulz, 1961-62

Captain William A. Earle, 1963-65

Captain Peter A. Morrill, 1965 *(west coast-east coast ferry run)*

Captain Archibald B. How, 1965-67

Captain Stephen G. Carkeek, 1967

Commander Harold A. Paulsen, 1968-71

Captain Edward D. Cassidy, 1972-73

Captain James C. Irwin, 1974-75

Captain James R. Kelly, 1975-76

Captain Paul A. Welling, 1976-80

Captain Martin J. Moynihan, 1980-83

Captain Ernst M. Cummings, 1983-1988

Captain David V. V. Wood, 1988-92

Captain Patrick M. Stillman, 1992-95

Captain Donald R. Grosse, 1995-1996

Captain Robert J. Papp, Jr., 1996-99

Captain Ivan T. Luke, Jr., 1999-2003

Captain Eric S. Shaw, 2003-06

Captain Joseph C. Sinnett, 2006-

Every few years—usually every three—the Coast Guard appoints a new commanding officer for *Eagle*.

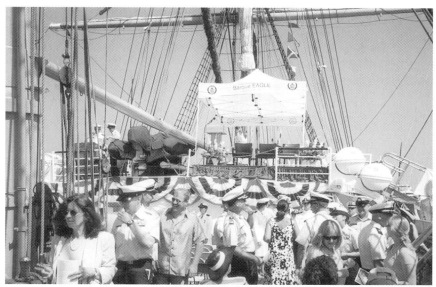

B - *Eagle*'s Crew

Eagle serves as a seagoing classroom for future Coast Guard officers. A permanent crew of six officers and 54 enlisted men and women maintain the ship all year and provide expert knowledge and seamanship for the training of up to 150 cadets or officer candidates at a time.

In addition to the Commanding Officer, *Eagle* also has a full-time Executive Officer, Operations Officer, Engineering Officer, Support Officer, and during training cruises, a Medical Officer.

The Operations Department consists of 25 personnel (average) who oversee the deck force, navigation, electronics, computers, security, and public affairs.

Eagle's Support Personnel consists of yeomen, storekeepers, medical, and food service specialists.

Eagle's Engineering Personnel are responsible for main propulsion, auxiliary systems, sewage, air conditioning and heating, and damage control.

The total number of crewmen aboard *Eagle* is augmented during training cruises. The maximum capacity is 239 people.

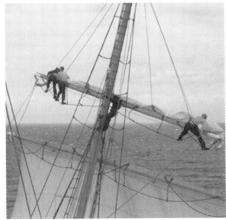

C - Cruises by SSS *Horst Wessel* and USCGC *Eagle*

Year	Itineraries
1936:	Kiel - Gotland, Sweden - Kiel - Las Palmas, Canary Islands - Kiel
1937:	Kiel - Canary Islands - Kiel - Molde, Norway - Pillau - Reykjavik, Iceland - Faeroe Islands - Kiel - Flensburg - Wilhelmshaven - Hamburg - Kiel
1938:	Kiel - St. Thomas, VI - Canary Islands - Kiel - Edinburgh - Balholm, Norway - Kiel - Travemünde - Kiel - Flensburg - Kiel - Stettin - Kiel - Lisbon, Portugal - Canary Islands - Kiel
1939:	Kiel - Molde, Norway - Kiel - Lübeck - Travemünde - Rügen - Kiel - Christiansand, Norway - Kiel
1940:	Kiel - Stralsund
1941:	Stralsund
1942:	Stralsund - Kiel
1943:	Kiel - Danzig
1944:	Danzig - Bornholm, Denmark - Rügen
1945:	Rügen - Flensburg - Wilhelmshaven - Bremerhaven
1946:	Bremerhaven - Plymouth, U.K. - Azores - Bermuda - New York City - CGA - Martha's Vineyard, MA - Nantucket, MA - New Bedford, MA - CGA
1947:	CGA - Bermuda - Caneel Bay, VI - San Juan, PR - Nassau, Bahamas - Miami, FL - Coral Gables, FL - Parris Island, SC - Norfolk, VA - New York City - CGA
1948:	CGA - Ponta Delgada, Azores - London, U.K. - Le Havre, France - Santa Cruz, Canary Islands - Bermuda - CGA
1949:	CGA - London, U.K. - Antwerp, Belgium - Lisbon, Portugal - Casablanca, Morocco - Santa Cruz, Canary Islands - CGA
1950:	CGA - Amsterdam, Holland - Antwerp, Belgium - La Coruna, Spain - Lisbon, Portugal - Madeira - CGA
1951:	CGA - London - Portsmouth, U.K. - Antwerp, Belgium - Amsterdam, Holland - Le Havre, France - Lisbon, Portugal - Casablanca, Morocco - Canary Islands - Halifax, NS - Bermuda - CGA
1952:	CGA - Oslo, Norway - Copenhagen, Denmark - Amsterdam, Holland - Santander, Spain - Tenerife, Canary Islands - Bermuda - CGA
1953:	CGA - Oslo, Norway - Antwerp, Belgium - Santander, Spain - Las Palmas, Canary Islands - CGA
1954:	CGA - Santander, Spain - Amsterdam, Holland - Copenhagen, Denmark - Bermuda - CGA
1955:	CGA - Glasgow, Scotland - Le Havre, France - Lisbon, Portugal - Madeira - Bermuda - CGA
1956:	CGA - San Juan, PR - Coco Solo, Panama - Havana, Cuba - Halifax, NS - CGA
1957:	CGA - Bergen, Norway - London, U.K. - La Coruna, Spain - CGA
1958:	CGA - Amsterdam, Holland - Dublin, Ireland - Lisbon, Portugal - Halifax, NS - CGA
1959:	CGA - San Juan, PR - Ciudad Trujillo, Dom. Rep. - Willemstad, Curacao - Kingston, Jamaica - Gardiners Bay, NY - Quebec City, Quebec - Nantucket, MA - Provincetown, MA - CGA
1960:	CGA - Oslo, Norway - Portsmouth, U.K. - Le Havre, France - CGA
1961:	CGA - Bordeaux, France - Lisbon, Portugal - Cadiz, Spain - Santa Cruz de Tenerife, Canary Islands - CGA
1962:	CGA - Edinburgh, Scotland - Antwerp, Belgium - Las Palmas, Canary Islands - Washington, DC - Yorktown, VA - Bermuda - CGA
1963:	CGA - Oslo, Norway - Amsterdam, Holland - Santander, Spain - Funchal, Azores - Madeira - CGA

1964: CGA - San Juan, PR - Bermuda - New York City - Quebec City, Quebec - Bermuda - CGA

1965: CGA - Miami, FL - Panama City, Panama - Acapulco, Mexico - Long Beach, CA - Seattle - San Francisco, CA - San Diego, CA -CGA

1966: CGA - Wilmington, NC - Boston, MA - CGA

1967: CGA - Montreal, Quebec - Cape May, NJ - Providence, RI - Nantucket, MA - CGA

1968: CGA - New York City - Provincetown, MA - Portsmouth, NH - Yorktown, VA - Bermuda - CGA

1969: CGA - Norfolk, VA - New York City - Portland, ME - Newport, RI - CGA

1970: CGA - Southport, NC - Portsmouth, VA - New York City - Newport, RI - CGA

1971: CGA – Bermuda - Boston, MA - Portsmouth, NH - Newburyport, MA - CGA

1972: CGA - Mobile, AL - New Orleans, LA - Galveston, TX - Portsmouth, U.K. - Lübeck - Travemünde - Kiel, Germany - Lisbon, Portugal - Madeira - CGA

1973: CGA - Boston, MA - San Juan, PR - Port Everglades, FL - Charleston, SC - New Bedford, MA - Newburyport, MA - Philadelphia, PA - CGA

1974: CGA - Washington, DC - Bermuda - Newport, RI - Boston, MA - New York City - Portsmouth, NH - New Bedford, MA - CGA

1975: CGA - Antwerp, Belgium - Le Havre, France - Rota, Spain - Malaga, Spain - Funchal, Madeira - CGA

1976: CGA - Philadelphia, PA - Alexandria, VA - Bermuda - Newport, RI - New York City - Baltimore, MD – Jacksonville, FL - Miami - Charleston, SC - New Bedford, MA - CGA

1977: CGA - Hamburg, Germany - London, U.K. - Rota, Spain - CGA

1978: CGA - Guantanamo, Cuba - Cristobal, Panama - Acapulco, Mexico - San Diego, CA - Victoria, BC - Vancouver, BC - Seattle - San Francisco, CA - Long Beach, CA - CGA

1979: CGA - Halifax, NS - Norfolk, VA - Washington, DC - New York City - Bermuda - Savannah, GA - CGA

1980: Boston, MA - St. Thomas, VI - San Juan, PR - Barbados - St. Lucia - Santo Domingo, Dom. Rep. - St. Petersburg, FL - Miami, FL - Charleston, SC - CGA

1981: CGA - Cork, Ireland - Lisbon, Portugal - Rota, Spain - Malaga, Spain - Las Palmas, Canary Islands - Bermuda - New Haven, CT - CGA

1982: CGA - Washington, DC - Norfolk, VA - Philadelphia, PA - Newport, RI - New York City - Portland, ME - CGA

1983: CGA - Port of Spain, Trinidad - St. Thomas, VI - Roosevelt Roads, PR - Port Everglades, FL Bermuda CGA

1984: CGA - New Orleans, LA - Halifax, NS - Quebec City, Quebec - Portsmouth, NH - Bourne, MA - CGA

1985: CGA - Cape Canaveral, FL - Mobile, AL - Jacksonville, FL - Bermuda - Boston, MA - St. Pierre et Miquelon - New Bedford, MA - Gloucester, MA - CGA

1986: CGA - Yorktown, VA - Bermuda - Washington, DC - Bermuda - Norfolk, VA - New York City - Halifax, NS - Newport, RI - Portland, ME - Portsmouth, NH - CGA

1987: CGA - New York City - CGA - Fall River, MA - New Bedford, MA - Palm Beach, FL - Rodman, Panama - Guyaquil, Ecuador - Galapagos, Ecuador - Papeete, Tahiti - Bora Bora/Society Islands/Pago Pago, Am. Samoa - Apia, Western Samoa - Nukualofa, Tonga - Vava'u, Tonga - New Castle, Australia - Brisbane, Australia

1988: Hobart, Tasmania - Sidney, Australia - Manly, Australia - Pago Pago, American Samoa - Honolulu, HI - Seattle, WA - San Francisco, CA - Long Beach, CA - Acapulco, Mexico - Rodman, Panama - Miami, FL - Edinburgh, Scotland - Bergen, Norway - Hamburg, Germany - Antwerp, Belgium - Santa Cruz, Canary Islands - Bermuda - CGA

1989: CGA - New York City - London, UK - Cork, Ireland - Leningrad, USSR - Aalborg, Denmark - Horseus, Denmark - Helsinki, Finland - Rouen, France - Horta, Azores - Halifax, NS - Portland, ME - Washington, DC - Savannah, GA - Yorktown, VA - CGA

1990: CGA - Tampa, FL - Mobile, AL - New Orleans, LA - Wilmington, NC - Washington, DC - Norfolk, VA - Portsmouth, VA - Cahrleston, SC - New York City - Boothbay Harbor, ME -

Boston, MA - Kenebunkport, ME - Philadelphia, PA - Baltimore, MD - Fall River, MA - Newport, RI - Portsnouth, NH - Halifax, NS - CGA

1991: CGA - Yorktown, VA - Ponta Delgada, Azores - Cherbourg, France - Weymouth, UK - Lisbon, Portugal - Funchal, Madeira - Bermuda - Gloucester, MA - Washington, DC - CGA

1992: CGA - Roosevelt Roads, PR - San Juan, PR - Nassau, Bahamas - New York City - Boston - Newport, RI - Portland, ME - Norfolk, VA - Morehead City, NC - Savannah, GA - CGA

1993: CGA - Dublin, Ireland - Oporto, Portugal - Cadiz, Spain - Funchal, Madeira - Bermuda - CGA

1994: CGA - Baltimore, MD - Washington, DC - Ponta Delgada, Azores - Plymouth, UK - Rouen, France - Bermuda - Newport, RI - CGA

1995: CGA - New York City - Norfolk, VA - CGA - Portsmouth, NH - Halifax, NS - Louisbourg, NS - Fall River, MA - CGA

1996: CGA - Dublin, Ireland - Amsterdam, Holland -Hamburg - Rostock, Germany - St. Petersburg, Russia - Helsinki, Finland - London, UK - Portsmouth, U.K. - Ponta Delgada, Azores - St. George, Bermuda - CGA

1997: CGA - Plymouth, UK - Kopengan, Denmark - Dan Helder, Holland - Bermuda - Norfolk, VA -CGA

1998: CGA - Roosevelt Roads, PR - Martinique, French Antilles - La Guaira, Venezuela - Cartagena, Columbia - CGA - New York City - Washington, DC - San Juan, PR - Miami - Savannah, GA - Boston, MA - Halifax, NS - Portland, ME - CGA

1999: CGA - Panama Canal - Acapulco, Mexico - San Francisco, CA - Portland, OR - San Diego, CA - Panama Canal - CGA

2000: CGA - Savannah, GA - CGA - Bermuda - San Juan, PR - Miami, FL - Norfolk, VA - New York City - CGA - Halifax, NS - Portland, ME - Newport, RI - Gloucester, MA - CGA - Boston, MA - CGA

2001: CGA - St. Johns, NF - Cork, Ireland - Brest, France - Lisbon, Portugal - Gibraltar - Bermuda - Norfolk, VA - New Bedford, MA - Fall River, MA - CGA - Greenport, NY - CGA

2002: CGA - New York City - Washington, DC - Nassau, Bahamas - Ft. Lauderdale, FL - Mobile, AL - Key West, FL - Charleston, SC - Norfolk, VA - Salem, MA - Boston, MA - Salem, MA - Halifax, NS - CGA

2003: CGA - Halifax, NS - CGA - Bermuda - Antigua - San Juan, PR - Trinidad - St. Maarten - Santo Domingo, Dom. Rep. - Wilmington, NC - Norfolk, VA - Annapolis, MD - Philadelphia, PA - Portland, ME - CGA

2004: CGA - Port Canaveral, FL - CGA - New York City - Savannah, GA - Key West, FL - Dry Tortugas - Fort Jefferson, FL - Nassau, Bahamas - Jacksonville, FL - Charleston, SC - Hamilton, Bermuda - Boston, MA - Newport, RI - CGA - Rockland, ME - St. John, NB - CGA - Portland, ME - CGA - Curtis Bay, MD

2005: Curtis Bay, MD - Little Creek, VA - Morehead City, NC - CGA - St. Johns, NF - Bremerhaven, Germany - Edinburgh, Scotland - Portsmouth, UK - Waterford, Ireland - Cherbough, France - Lisbon, Portugal - Rota, Spain - Madeira - Tenerife, Canary Islands - Hamilton, Bermuda - CGA

2006: CGA - Little Creek, VA - Savannah, GA - CGA - New York City - Washington, DC - Norfolk, VA - New London, CT - Hamilton, Bermuda - San Juan, PR - Charleston, SC - Newport, RI - Portsmouth, NH - Boston, MA - Greenport, NY - Halifax, NS - CGA

2007: CGA - San Juan, Porto Rico - Barbados - St. Maarten - San Juan, Puerto Rico - Caribbean ports - Norfolk, VA - CGA

2008: (Planned) CGA - Mazatlan, Mexico - San Diego - Astoria, Oregon - Victoria, B.C. - Tacoma, WA - San Francisco - Los Angeles - Panama City, Panama

D. Barque *Eagle* and Her Sisters

1. **Gorch Fock** - Commissioned in 1933 as the Segelschulschiff *Gorch Fock,* served as sail-training ship until 1939. During World War II she was decommissioned and re-commissioned, and scuttled by her crew in May 1945 outside Stralsund. She was raised in 1947, re-conditioned, and in 1949 was commissioned *Tovarisch* in Soviet Navy. In 1989, after the break-up of Soviet Union, she was awarded to Ukraine. She was taken to England 1995 for repairs and was subsequently purchased by the German organization "Tall Ship Friends." She was carried to Stralsund by a dock ship in 2003, renamed *Gorch Fock*, and is currently being refurbished.

2. **Eagle** - Commissioned in 1936 as Segelschulschiff *Horst Wessel,* she served as sail-training ship until 1939, decommissioned and re-commissioned. In 1945 she was claimed as a war prize by the United States, and commissioned as the training ship Barque *Eagle* in the U.S. Coast Guard.

3. **Sagres** - Commissioned in 1936 as Segelschulschiff *Albert Leo Schlageter,* she served as sail-training ship until 1939. During World War II she was decommissioned, then recommissioned. In 1946 she was claimed as a war prize by the United States and sold to Brazil in 1948 for $5,000. She served in Brazilian service as he *Guanabara* until 1961 when was purchased by Portugal in 1962. She has served in Portugese service ever since as the *Sagres*.

4. **Mircea** - Commissioned 1938 as the *Mircea* for the Romanian Navy, she has remained in the same service since.

6. **Herbert Norkus** - Built in 1939 as Segelschulschiff *Herbert Norkus* for German Navy, never completed, claimed as a war prize by Great Britain and in 1946 was filled with ammunition and sunk in the North Sea.

5. **Gorch Fock II** - Commissioned in 1956 as the Segelschulschiff *Gorch Fock* for the Federal German Navy.

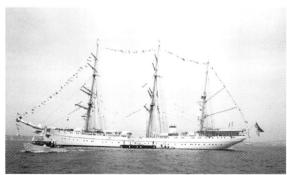

Gorch Fock II

PHOTOGRAPHY CREDITS

Frontispiece/ Page 4 - Author's Collection; U.S. Coast Guard
Page 8 Peter Barlow, Pawcatuck, CT
Page 11 (2) U.S. Coast Guard
Page 12 (2) Author's Collection; (2) U.S. Coast Guard
Page 13 U.S. Coast Guard; Author's Collection; Peter Barlow, Pawcatuck, CT
Page 14 U.S. Coast Guard; Peter Barlow, Pawcatuck, CT
Page 15 (2) Flottenbilder, M. Brinkman AG, Bremen
Page 16 H. Fischer, Gifhorn, Germany; Author's Collection
Page 17 (2) Blaine Pardoe
Page 18 Blaine Pardoe
Page 19 (2) U.S. Coast Guard
Page 20 U.S. Coast Guard
Page 21 (2) Blohm + Voss
Page 22 (2) Blohm + Voss
Page 23 (2) Blohm + Voss
Page 24 W. Starck, Hamburg, Germany; Blohm + Voss
Page 25 Blohm + Voss
Page 26 KM Unterrichtsheft
Page 27 U. Bartels, Ratzenburg, Germany; Author's Collection
Page 28 Blohm + Voss
Page 29 Schiffsbuch für *Horst Wessel*; S. Stiller, Harrislee, Germany
Page 30 U.S. Coast Guard
Page 31 U.S. Coast Guard
Page 32 Schiffsbuch für *Horst Wessel*
Page 33 Author's Collection
Page 34 Author's Collection; Author Drawing
Page 35 H. Wagner, Stuttgart, Germany
Page 36 Author's Collection; U.S. Coast Guard
Page 37 U.S. Coast Guard; Brigitte Jakob, Arnis, Germany
Page 38 Brigitte Jakob, Arnis, Germany; (2) Author's Collection
Page 39 (2) U.S. Coast Guard
Page 40 (2) U.S. Coast Guard
Page 41 (2) U.S. Coast Guard
Page 42 (2) U.S. Coast Guard
Page 43 (2) U.S. Coast Guard
Page 44 (2) U.S. Coast Guard
Page 45 (2) U.S. Coast Guard
Page 46 (3) U.S. Coast Guard
Page 47 (2) S. Stiller, Harrislee, Germany
Page 48 (2) U.S. Coast Guard
Page 49 U.S. Coast Guard
Page 50 (2) U.S. Coast Guard
Page 51 U.S. Coast Guard
Page 52 U.S. Coast Guard; Author's Collection
Page 53 (2) U.S. Coast Guard
Page 54 (2) G. Becker, Weisbaden, Germany
Page 55 Author's Collection
Page 56 J. Gumprecht, Seefeld, Germany; G. Bender, Raisdorf, Germany
Page 57 Author's Collection
Page 58 Author's Collection; W. Ricker, Eislingen, Germany
Page 59 (2) Author's Collection
Page 60 K. Cociancig, Braunau, Austria; G. Mayer-Harnisch, Arroyo Grande, CA
Page 61 G. Mayer-Harnisch, Arroyo Grande, CA
Page 62 (3) G. Mayer-Harnisch, Arroyo Grande, CA
Page 63 G. Mayer-Harnisch, Arroyo Grande, CA
Page 64 (2) G. Mayer-Harnisch, Arroyo Grande, CA
Page 65 G. Mayer-Harnisch, Arroyo Grande, CA
Page 66 (2) G. Mayer-Harnisch, Arroyo Grande, CA
Page 67 G. Mayer-Harnisch, Arroyo Grande, CA
Page 68 (3) G. Mayer-Harnisch, Arroyo Grande, CA
Page 69 (2) G. Mayer-Harnisch, Arroyo Grande, CA
Page 70 G. Mayer-Harnisch, Arroyo Grande, CA
Page 71 G. Mayer-Harnisch, Arroyo Grande, CA; G. Becker, Wiesbaden, Germany
Page 72 Author's Collection

Page 73 G. Strauss, Esslingen, Germany
Page 74 H. Meinke, Putbus, Germany
Page 75 Author's Collection
Page 76 P. Schnibbe, Bremen, Germany; U.S. Coast Guard
Page 77 (2) U.S. Coast Guard
Page 78 U.S. Coast Guard; G. Mayer-Harnisch, Arroyo Grande, CA
Page 80 (2) U.S. Coast Guard
Page 81 U.S. Coast Guard; Author's Collection
Page 82 U.S. Coast Guard; G. Mau, Flensburg, Germany
Page 83 U.S. Coast Guard; Flat Hammock Press
Page 84 (2) U.S. Coast Guard
Page 85 (3) G. Mau, Flensburg, Germany
Page 86 (2) G. Mau, Flensburg, Germany
Page 87 (G. Mau, Flensburg, Germany; Author's Collection
Page 88 (3) Author's Collection; Peter Barlow, Pawcatuck, CT
Page 89 U.S. Library of Congress
Page 90 Author's Collection
Page 91 (2) U.S. Coast Guard
Page 92 U.S. Coast Guard
Page 93 (2) U.S. Coast Guard
Page 94 (2) U.S. Coast Guard
Page 95 (2) U.S. Coast Guard
Page 96 (2) U.S. Coast Guard
Page 97 (2) U.S. Coast Guard
Page 98 (2) U.S. Coast Guard
Page 99 Peter Barlow; Garrett Conklin, Alameda, CA; Peter Barlow
Page 100 (2) U.S. Coast Guard
Page 101 (2) Peter Barlow, Pawcatuck, CT
Page 102 NASA Photo; Capt. David V. V. Wood, USCG (Ret.), Newport, RI
Page 103 U.S. Coast Guard
Page 104 U.S. Coast Guard; S. Stiller, Harrislee, Germany
Page 105 (2) Capt. David V. V. Wood, USCG (Ret.), Newport, RI
Page 106 U.S. Coast Guard; (2) Author's Collection
Page 107 U.S. Coast Guard; Author's Collection; Peter Barlow, Pawcatuck, CT
Page 108 Author's Collection; (2) Capt. Ernst M. Cummings, USCG (Ret.), Newport, RI
Page 109 Author's Collection; Peter Barlow, Pawcatuck, CT
Page 110 (3) Capt. Ivan T. Luke, USCG, Newport, RI
Page 111 (2) U.S. Coast Guard
Page 112 (2) Author's Collection
Page 113 (2) U.S. Coast Guard; Peter Barlow, Pawcatuck, CT
Page 114 U.S. Coast Guard
Page 115 U.S. Coast Guard; (2) Flat Hammock Press
Page 116 (2) Author's Collection
Page 117 (2) Author's Collection
Page 118 C. Baier, West Simsbury, CT; (2) Author's Collection
Page 119 Capt. Ivan T. Luke, USCG, Newport, RI; Capt. Ernst M. Cummings, USCG (Ret.), Newport, RI
Page 120 (2) Capt. Ernst M. Cummings, USCG (Ret.), Newport, RI
Page 121 (2) Capt. Ernst M. Cummings, USCG (Ret.), Newport, RI
Page 122 Capt. Ernst M. Cummings, USCG (Ret.), Newport, RI
Page 123 (3) Capt. Ernst M. Cummings, USCG (Ret.), Newport, RI
Page 124 (3) Capt. Ernst M. Cummings, USCG (Ret.), Newport, RI
Page 125 (3) Capt. Ernst M. Cummings, USCG (Ret.), Newport, RI
Page 126 (3) Capt. Ernst M. Cummings, USCG (Ret.), Newport, RI
Page 127 (3) Capt. Ernst M. Cummings, USCG (Ret.), Newport, RI
Page 128 (2) Capt. Ernst M. Cummings, USCG (Ret.), Newport, RI
Page 129 Capt. Ivan T. Luke, USCG, Newport, RI
Page 130 Tamara McKenna, Mystic, CT; Capt. David V. V. Wood, USCG (Ret.), Newport, RI
Page 131 Tamara McKenna, Mystic, CT; (2) Capt. David V. V. Wood, USCG (Ret.), Newport, RI
Page 132 Karl Dillman, Kingston, RI; Capt. David V. V. Wood, USCG (Ret.), Newport, RI
Page 133 (2) Capt. David V. V. Wood, USCG (Ret.), Newport, RI
Page 134 U.S. Coast Guard
Page 135 Author's Collection
Page 136 (2) Author's Collection
Page 137 Author's Collection
Page 138 (2) Author's Collection
Page 139 (2) Author's Collection
Page 140 (3) Author's Collection
Page 141 Capt. Ivan T. Luke, USCG, Newport, RI
Page 142 (2) Author's Collection
Page 143 (4) Author's Collection
Page 144 Peter Barlow, Pawcatuck, CT; (2) Capt. Ivan T. Luke, USCG, Newport, RI
Page 145 (2) Capt. Ivan T. Luke, USCG, Newport, RI
Page 146 Flat Hammock Press; Capt. Ivan T. Luke, USCG, Newport, RI; NOAA Photo
Page 147 Romanian Embassy; (2) Author's Collection
Page 148 J. Ditzen-Blanke, Bremerhaven, Germany; H. Westphal, Lüdenscheid, Germany
Page 149 Author's Collection; (2) U.S. Coast Guard
Page 151 (2) Author's Collection
Page 152 U.S. Coast Guard; Capt. Ivan T. Luke, USCG, Newport, RI
Page 153 Author's Collection; (2) Capt. Ivan T. Luke, USCG, Newport, RI
Page 157 Author's Collection

AFTERWORD

Looking back on her history, we can see that *Horst Wessel* was originally intended for young men who would eventually move into commanding positions in the German Navy. The German Navy under the Kaiser was named *Kaiserliche Marine* (Imperial Navy), after the First World War in the Weimar Republic the name changed to *Reichsmarine* (Navy of the Reich). In 1935 Adolf Hitler changed the name to *Kriegsmarine* (War Navy). And while most young men of those years did not realize it, the name change turned out to be a prophetic one, as their leader intended them to go to war soon, to a terrible, long war.

It seems fitting that since 1946—for more than 60 years—*Eagle* has helped educate young men and women aspiring to a career in the U.S. Coast Guard, a service which exists not to train young people to do battle, but to help, protect, and if necessary, to save lives.

Except for her first ten years, our "Perfect Lady" has spent her life in a noble profession indeed.

May our "Perfect Lady" continue for many more years to come!

Tido Holtkamp